NORTHWICH
THROUGH TIME

Paul Hurley

AMBERLEY PUBLISHING

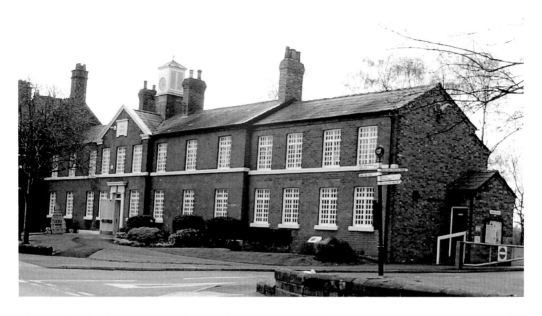

The Northwich Salt Museum, built originally as the Northwich Union workhouse in 1837-9 in London Road. It cost £4,500 and was designed by George Latham.

First published 2009

Amberley Publishing Plc
Cirencester Road, Chalford,
Stroud, Gloucestershire, GL6 8PE

www.amberleybooks.com

British Library Cataloguing in Publication Data.
A catalogue record for this book is available from the British Library.

ISBN 978 1 84868 719 6

Typesetting and Origination by Amberley Publishing.
Printed in Great Britain.

Introduction

'Northwich is a dream town of fanciful creation by a disordered brain. The streets swagger at concentric angles and the houses lurch forward drunkenly whilst in the dwellings the people assume the impossible attitudes similar to those seen in a freak mirror. There is no architectural dignity in Northwich shops and cottages pitched forward like drunken men. Churches and schools assume irreverent postures like those of a ballet girl with one leg in the air. Recently the post office was disporting itself on stilts and the public library was straining its cupola in an attempt to look over the adjoining public house.'

The above was part of an article in the *Sunday Chronicle* of 1907; this was at the height of the spectacular and destructive subsidence that Northwich suffered. This problem prevailed in most of mid Cheshire but Northwich took the brunt of its effects. As can be seen from this selection of old photographs, buildings simply collapsed or slid slowly and sometimes not so slowly into the ground. The wild brine pumping had left vast underground chasms and eventually the ground above would sink into them. On occasions this would happen on open land causing a deep lake known as a flash, sometimes as in some of these photos it would happen in heavily populated areas and the town centre.

I have tried where possible to replicate the old photographs with new ones; in most cases the reader can identify something still there after all of the years. Sometimes buildings and views have changed and in this case I have used the vantage point of the photographer of old to show what the scene now looks like.

Those interested in local history will hopefully gain enjoyment from the work but a book such as this with its then and now photographs is aimed at all readers. So whatever your interest and local knowledge, whether you are a local history enthusiast, someone who enjoys a trip into the past or just have a casual interest in what things once looked like, enjoy the book as I have enjoyed compiling it.

Paul Hurley
June 2009

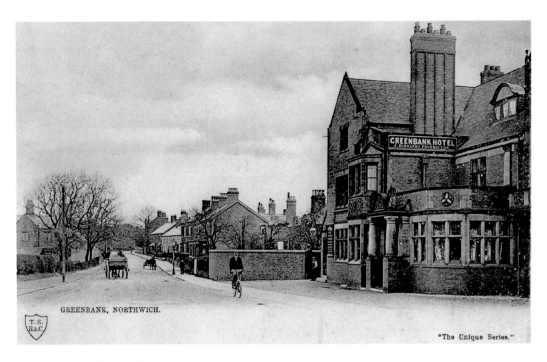

GREENBANK, NORTHWICH.

T.S.
B.&C.

"The Unique Series."

The Greenbank Hotel, 1908 and 2009

We start our trip through Northwich at the Greenbank Hotel on Chester Road. This large and imposing hotel was built in 1894 and provided accommodation for users of the adjoining Greenbank station. Permission to build it was only granted on condition that others nearby were closed.

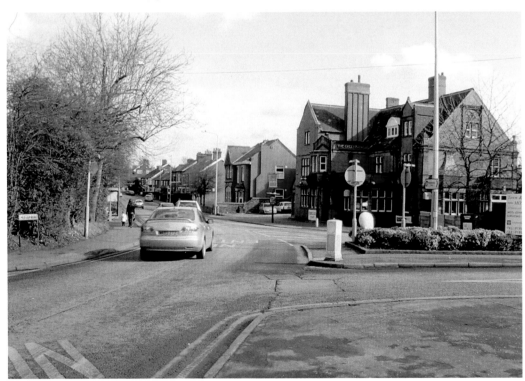

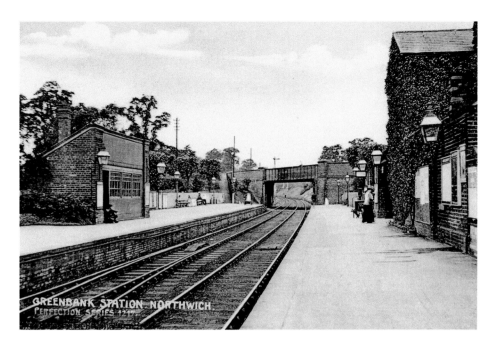

Greenbank Station, 1900-09 and 2009

Sitting astride the Manchester to Chester line part of the Cheshire Lines Committee the station was originally called Hartford and Greenbank. The name was changed to simply Greenbank to avoid confusion with the nearby Hartford Station on the West Coast Main Line. The station buildings have now been converted into a church and as can be seen, little has altered on the platform side over the years.

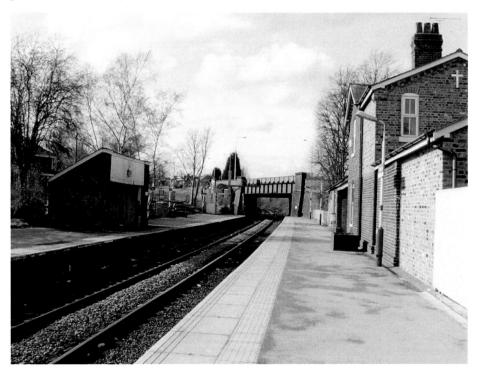

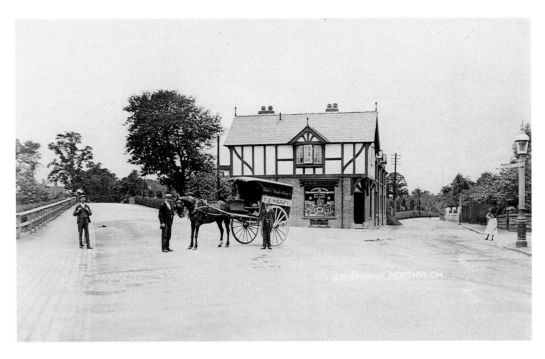

Greenbank Junction 1920 and 2009

These photos show the junction with Chester Road and the strangely named Beach Road. Little has changed, but the shop in the centre has had several uses over the years. It's lucky that it's still there as this junction was very precarious in the days of pea souper smogs; I well remember the flickering oil lamps that used to be put where the island is.

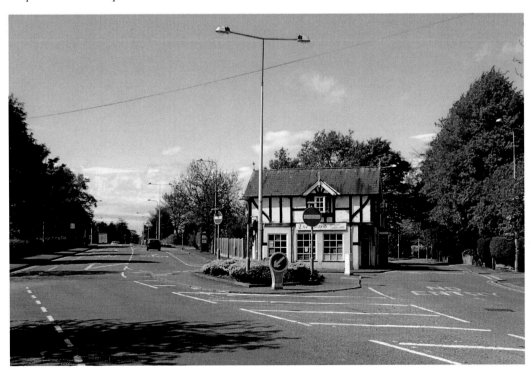

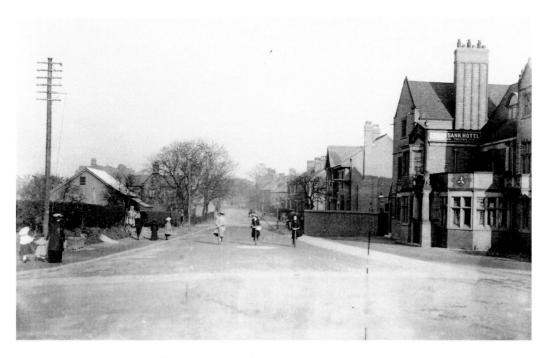

Chester Road Greenbank 1920s and 2009

Another old view of Chester Road taken at the turn of the century, the ladies on their bicycles would not be able to ride so casually now. They are in the middle of one of the main roads into the town! The modern photo shows the road at one of its few quiet periods.

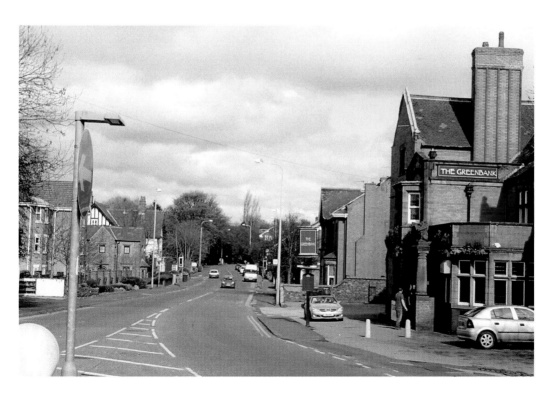

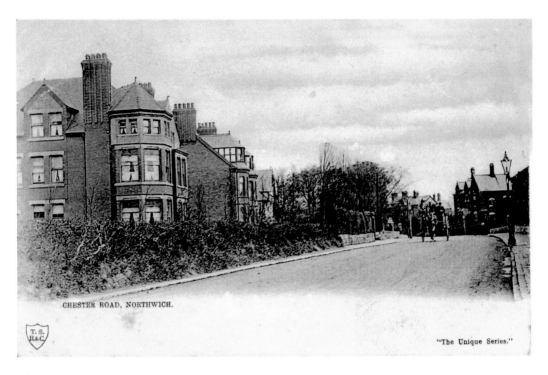

CHESTER ROAD, NORTHWICH.

"The Unique Series."

Chester Road 1904 and 2009

Continuing past the Greenbank Hotel we come to an old postcard scene from 1904. The house was quite new and situated in one of the more affluent areas. This area will have been developed with the nearby railway station in mind. The modern photo show that trees now obscure most of the houses but the one in the old photo can be seen peeping between the foliage!

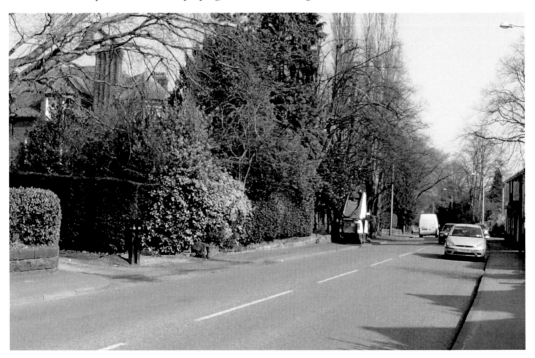

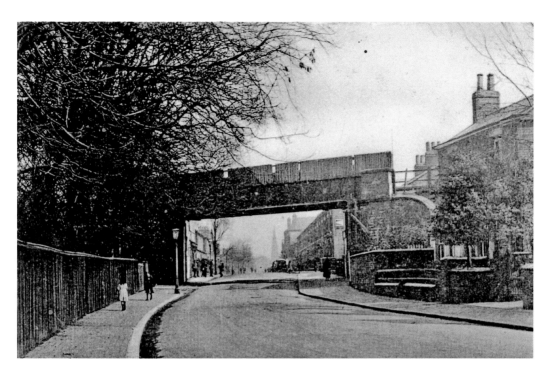

Iron Bridge 1905 and 2009

At the junction with Chester Road and Moss Road a railway bridge know locally as the Iron Bridge passes over the road. The old photo was taken around 1905 when the line was owned by the Cheshire Lines Commission and carried a spur from the Chester Manchester line to the Brunner Mond works at Winnington. Later part of the ICI Light Railway, it is now rarely used.

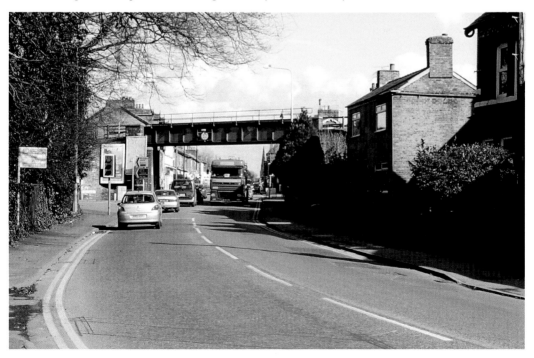

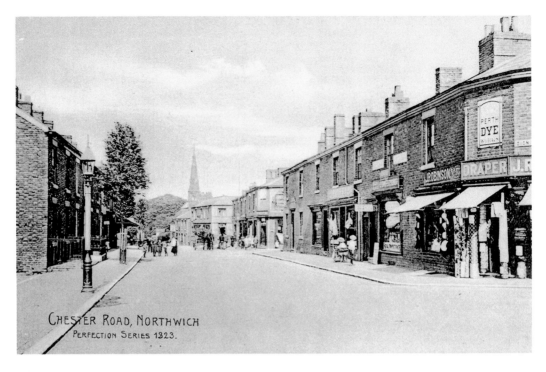

CHESTER ROAD, NORTHWICH
PERFECTION SERIES 1323.

Chester Road 1893 and 2009

This is Chester Road — the name will soon change to Castle Street and thence down Castle Hill into Northwich. In the old photo dating from the 1893 we can see just how little has changed over the years. The Castle area is steeped in history, the ancient name is Castleton and many Roman artefacts have been discovered here.

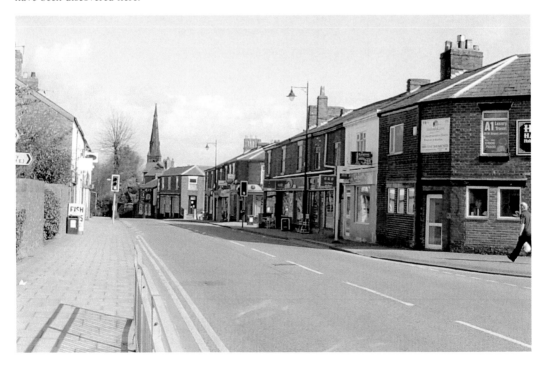

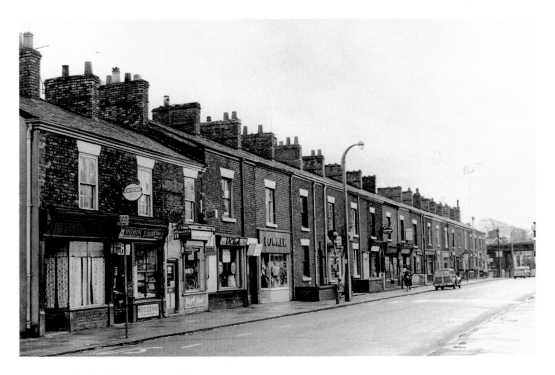

Castle in the 1960s and 2009

Looking back towards the Iron Bridge we see a row of terraced shops. Since the 1960s the first house has been demolished, the outline can still be seen on the nearest gable end. Off one side of the road large imposing houses could be found and off the other, a myriad of terraced streets.

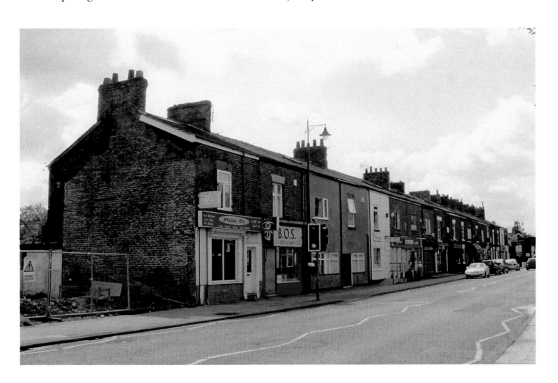

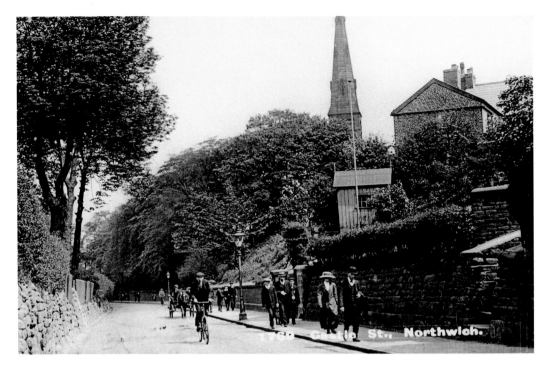

Castle Hill 1910 and 2009

The top of Castle Hill around 1910 and in the later photograph the scene has changed little; the pedal cycle in the old photo has become a motor scooter in the new. A sign of the times could be the polythene in the branches, will the sweeper driver remove it do you think? The Holy Trinity church was built in 1842 for the watermen and their families. In 1899, shortly before the photo was taken a new organ costing £375 had been installed.

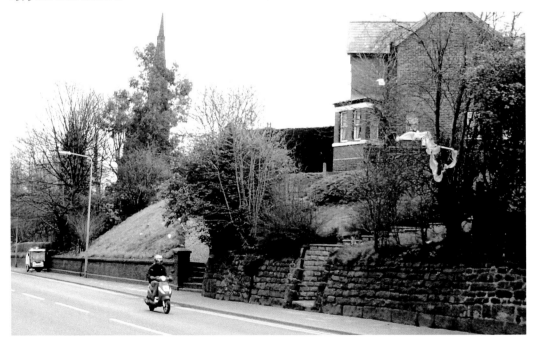

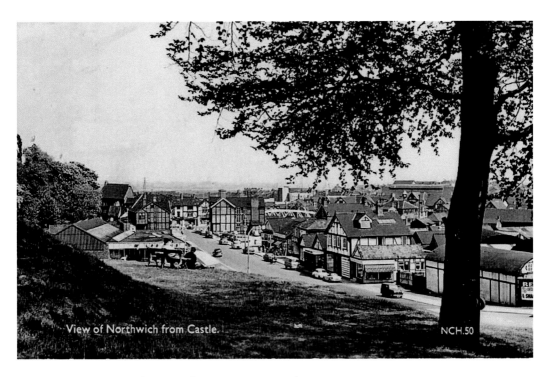

View of Northwich from Castle. NCH.50

From Witton Park to Castle Street 1964 and 2009

These photographs give an insight into the changes in this area over 40 years. The Wheatsheaf is nearer the camera but obscured, it was one of the town's busiest hotels in the late nineteenth and early twentieth centuries and suffered severe subsidence damage. It was not however demolished until the 1970s.

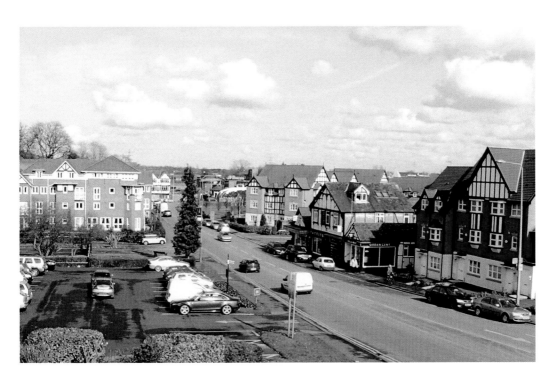

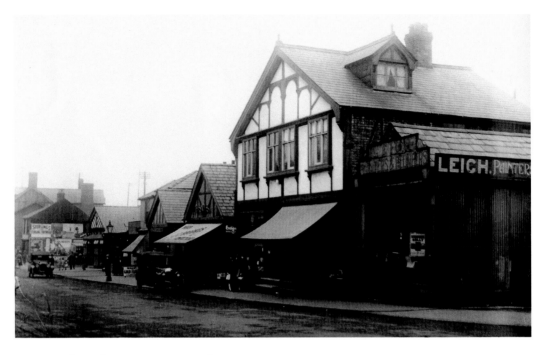

Bottom of Castle Street 1920s and 2009

The longevity of the building in the picture can be put down to its ability to be jacked up, thereby making good the effects of subsidence. In the older photo taken in the early 1920s the firm of George and William Leigh, painters can be seen. Amazingly this small apparently flimsy building is still fit and well almost 90 years later when a hairdresser is in residence.

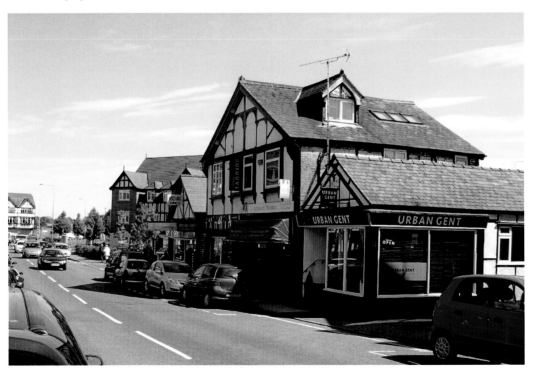

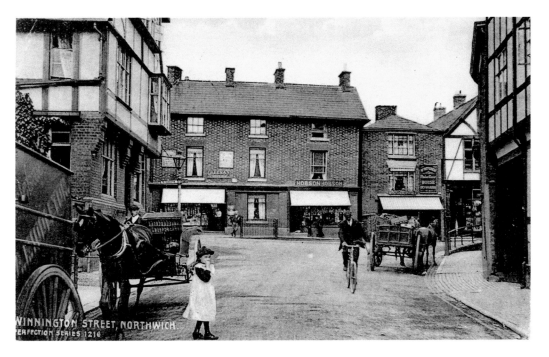

Bottom of Castle Street 1900 and 2006

This evocative shot is of the area known as the Holloway in days past; at one time this was a very busy part of the town but suffered greatly from subsidence. I have taken the liberty of using a 2006 photograph to illustrate the modern aspect. This shows the buildings to the right that have since been demolished and the main building has yet to be boarded up. The far black and white building is *in situ* in the old photo.

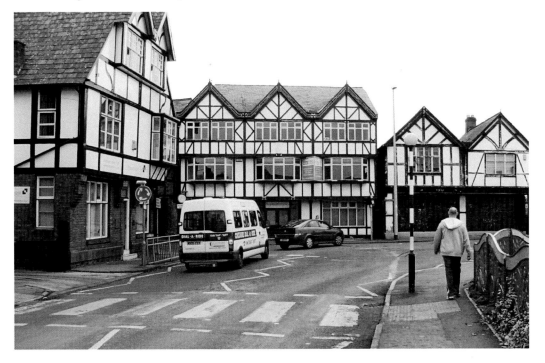

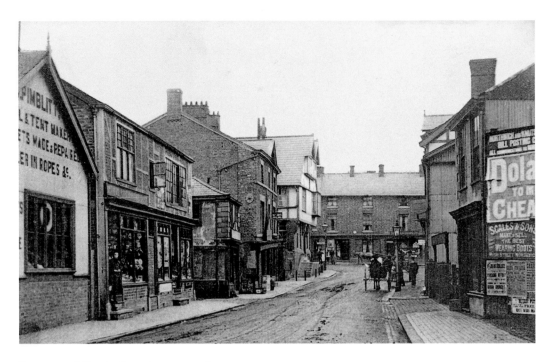

Bottom of Castle Street 1910 and 2009

In the same area, apart from the interesting old photo the large black and white building has been boarded up but is still for sale. The offices of Mosshaselhurst on the left are a focal point in these photos. The church that was on the site having succumbed to subsidence, the office block was built to the new specifications with a steel raft base capable of being jacked up. Its longevity proves that it worked!

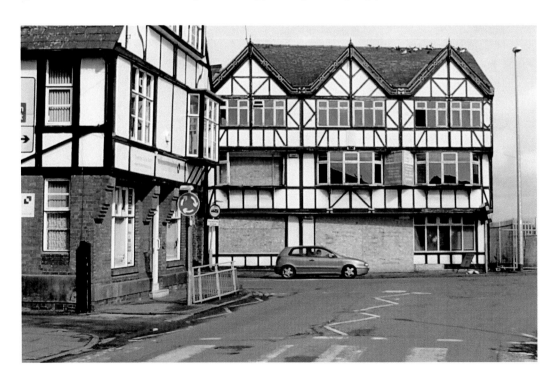

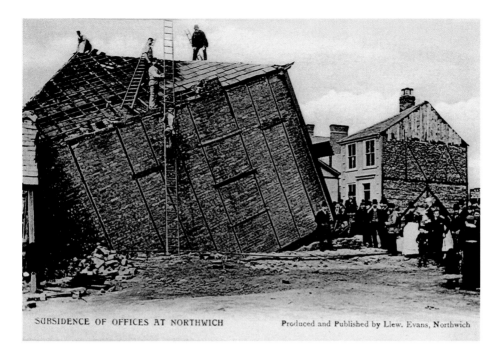

SUBSIDENCE OF OFFICES AT NORTHWICH Produced and Published by Llew. Evans, Northwich

Lower Castle Street 1903 and 2009

Here we see a prime example of the devastation caused to certain areas of Northwich as a result of brine pumping. Much has already been written about the period when buildings simply slid into the ground beneath them. In this selection of photographs from 1903 a building known as Castle Chambers has fallen backwards into a hole. As a result of this spectacular subsidence the firm of J.J. Dixon & Son Solicitors re-located to Witton Street.

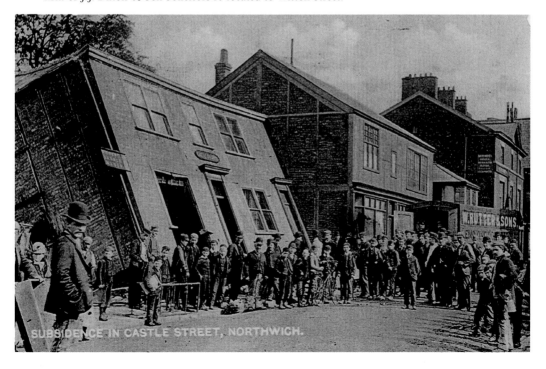

SUBSIDENCE IN CASTLE STREET, NORTHWICH.

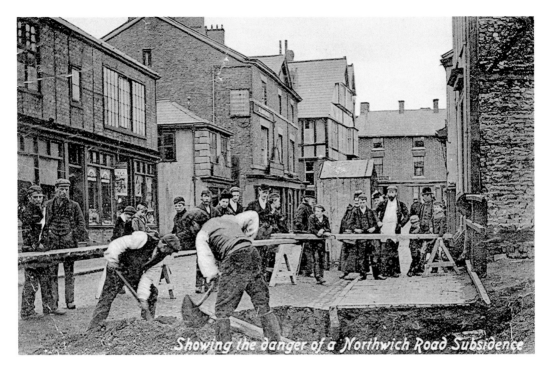

Showing the danger of a Northwich Road Subsidence

As workmen repair the damage we see a modern photograph of the area.

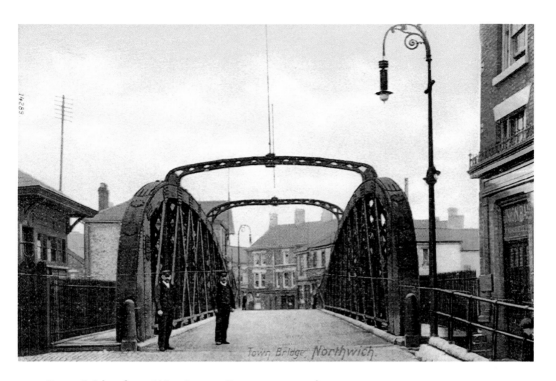

Town Bridge from Winnington Street 1910 and 2009

Still in the area once known as the Holloway and leading towards the Town Bridge. The bridge was the second of its type, the first being Hayhurst Bridge in Chester Way which was built in 1898, and this, the Town Bridge in 1899, both were designed by Colonel John Saner. The bridges were the first two electrically-powered swing bridges in Great Britain and were built on floating pontoons to counteract the subsidence.

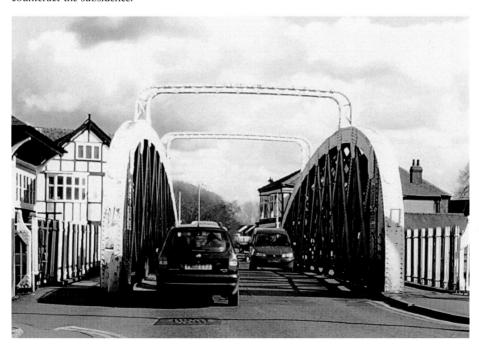

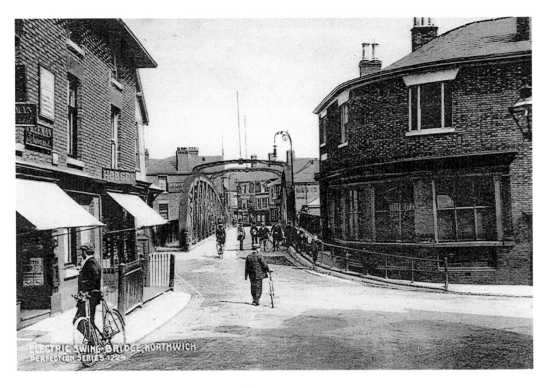

Lower Winnington Street 1910 and 2009

Another view of the bridge which has changed remarkably little over the 100 years since it was opened. Between the end of the building on the left and the bridge gate house is Lock Street, once a busy street leading to Northwich locks. Now a path alongside the river leading to Furey Wood, one time waste tip for Brunner Mond and then a corporation tip it has been reclaimed and turned into a beauty spot.

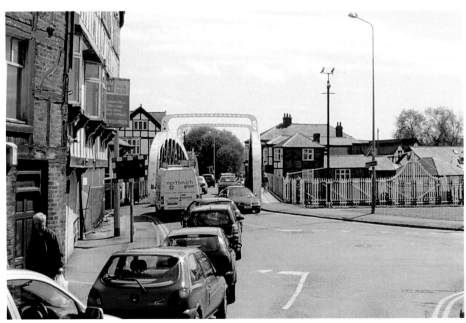

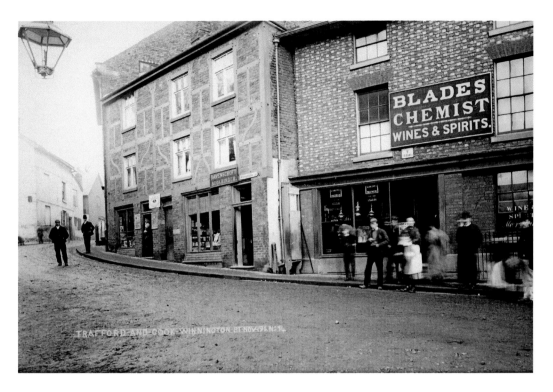

Winnington Street 1891 & 2009

In the photo taken on the 19th November 1891 Blades the chemist can be seen with Ravenscroft the bookbinder further up Winnington Street. This is at the bottom where Winnington Street joins Castle Street.

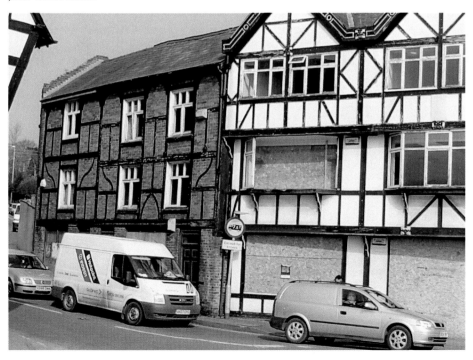

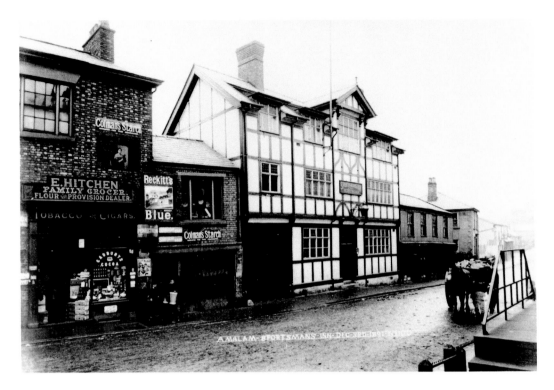

The Sportsman 1895 & 2009

This large black and white hotel was at the bottom of Castle Street and was built in 1776. Originally known as the 'New Eagle and Child', its name changed to the Sportsman in 1820. Despite suffering the effects of subsidence it lasted until 1976 before it was finally demolished. As can be seen from the 2009 view, the area has now been grassed over and adjoins a new development of private flats.

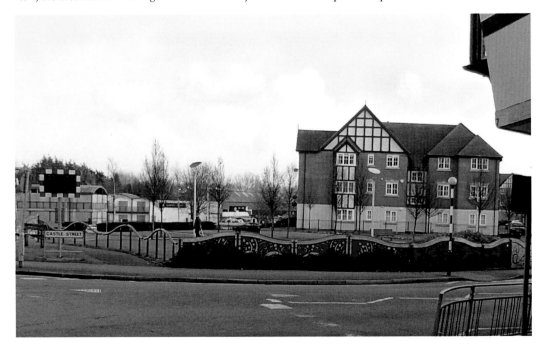

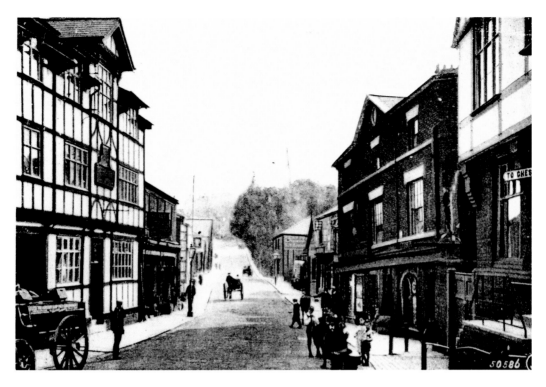

Castle Street, pre-1920 and post-1920

In the post-1920s shot we see the car showroom and petrol station that replaced the large building in 1920. Believed to be the first of its kind in Northwich, during the 1950s the showroom moved to larger premises next door. This in turn made way for retirement flats. The old showroom which still has the word 'GARAGE' set in leaded glass above the door became a carpet shop and then a bar, one of its later names being J.W.'s Wine Bar.

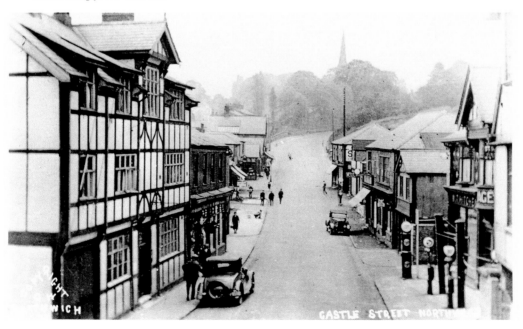

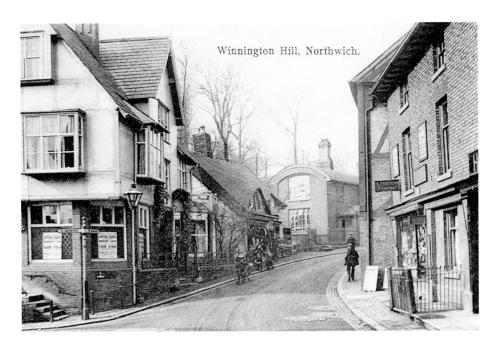

Winnington Hill, Northwich.

Winnington Hill 1900s and 2009

Another photo of the Holloway area taken around the time of the first war, this shows the front steps on the building in the foreground. These have now gone and the door step is level with the road. The barrel roofed building next to Joe Allman's old cottage is built in the canal style and the modern photo shows the building that replaced it. Joe Allman's cottage, ancient though it was, has been pulled down.

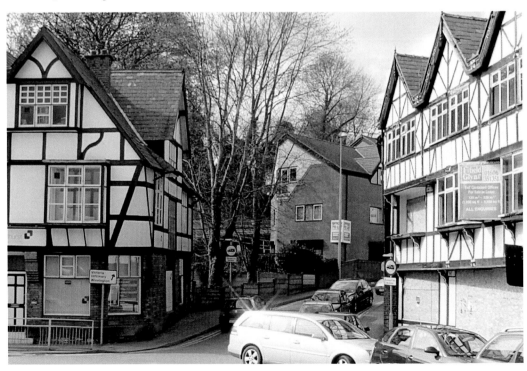

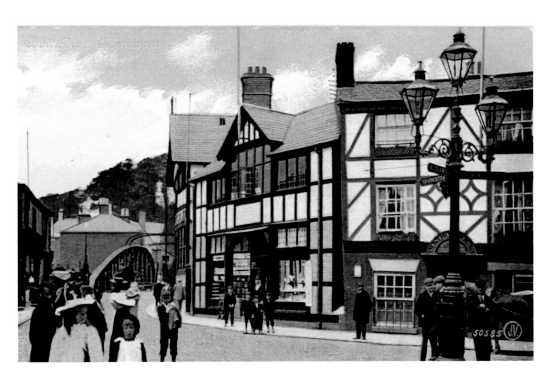

Bull Ring after 1899 and 2009

This is the earliest view dated not long after the swing bridge was built in 1899 and although the Brittania building is not in view, it is there but the photo was taken from a slightly different angle. Like the building on the right of it, it is there throughout.

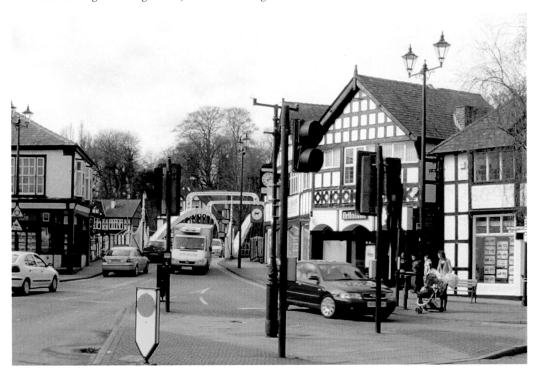

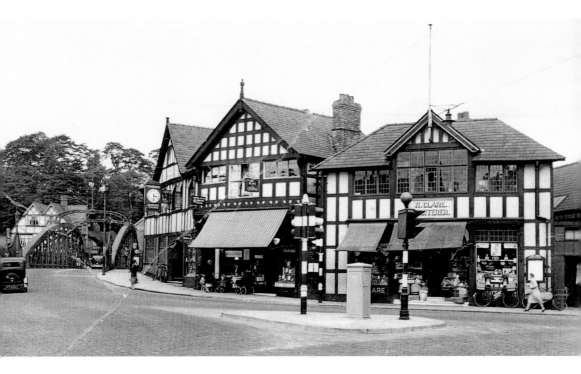

Bull Ring 1930 and 1950s

In the 1930 photograph little activity is taking place, a few pedestrians and a lone boy watching the photographer. Fast forward 20 years to the 1950s and it is a different matter. The stone sets have been covered in tarmac and Home and Colonial has opened on the right of the picture.

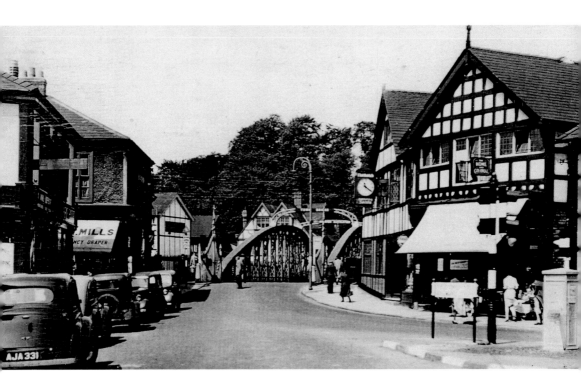

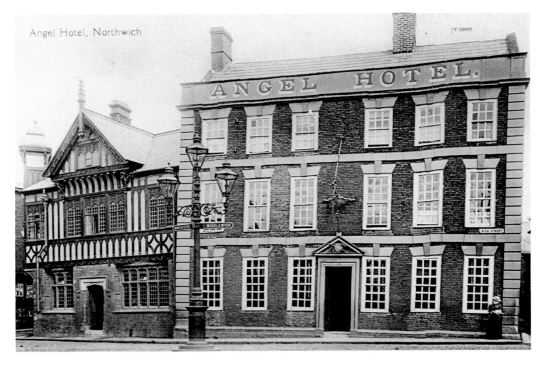

Angel Hotel, Northwich

Bull Ring with Angel Hotel and Bull Ring speech

No photo of the Bull Ring is complete without a view of the Angel Hotel. This building was built in 1790. When the subsidence started it suffered spectacularly leading to its demolition in 1922. In this turn of the century photo the subsidence has started as can be seen. In the second photo taken on the 10th May 1910 we see the town's dignitaries announcing the accession of King George V in front of the hotel.

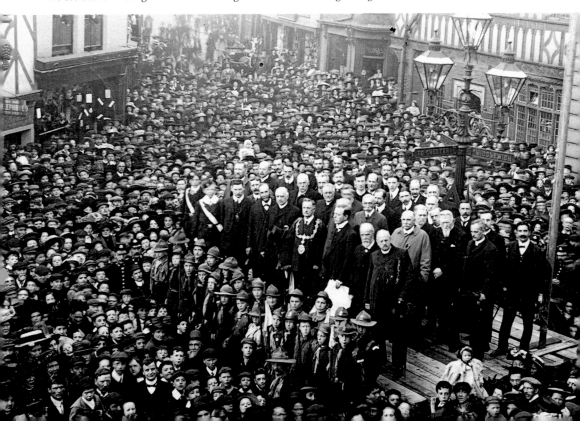

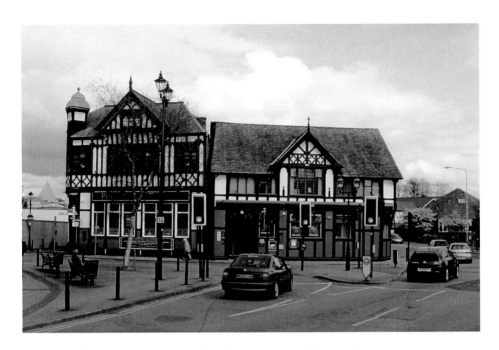

Photo of the Bull Ring 2009 and Bull Ring Gas Holder 1960s

In 1930 the building shown was built on the site of the Angel Hotel. The building next door has existed from the 1800s having been lifted and repaired after subsidence; it now houses the Pink Olive restaurant. The door was originally in the centre of the front elevation but is now on the corner. Later photos will show this. The 1960s photo shows the buildings from the same vantage point, in the photograph the town's gasometer dominates but was demolished some years ago.

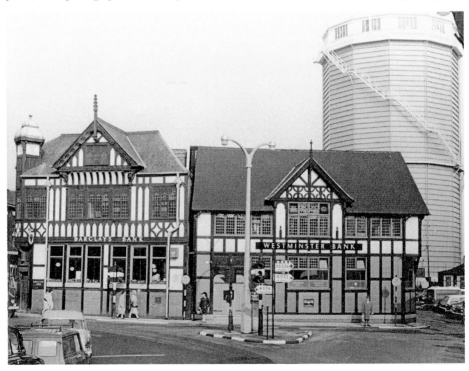

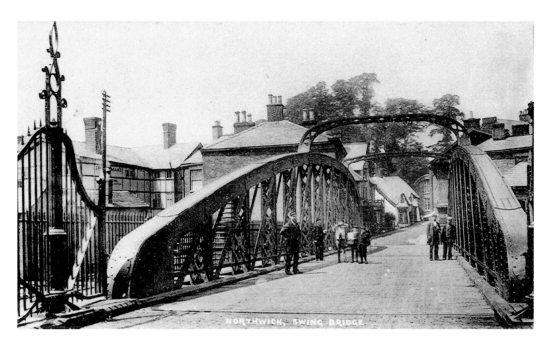

Town Bridge 1900 and Town Bridge 2009

Here is an excellent example of the success that this old bridge has been. Albeit that it was renovated a few years ago it was most certainly not built to take the weight of the huge Norbert Dentressangle arctic unit that is crossing.

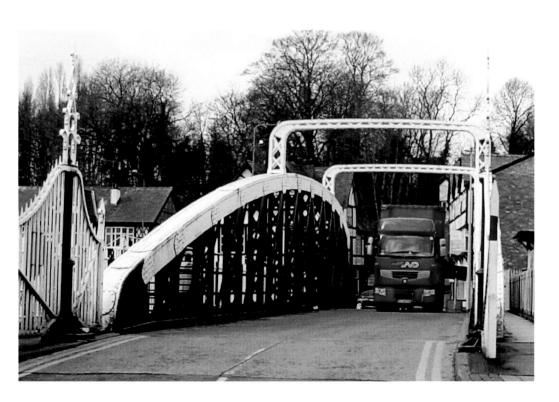

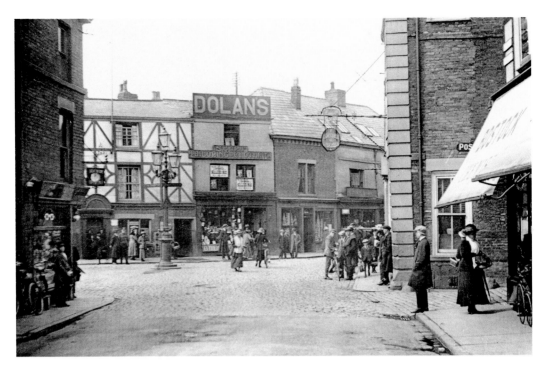

Dolans Bullring 1910 and 2009

This evocative photograph taken between 1910 and 1920 is a view into the Bullring from Dane Street and shows the store of Dolan Brothers clothiers at 9 High Street. The corner of the Angel Hotel can be seen on the right. Just before it is the opening to Church Street, once a narrow road passing the ancient market hall it's now a major thoroughfare called Watling Street which boasts the town's bus station, if a few bus stops can be called a bus station!

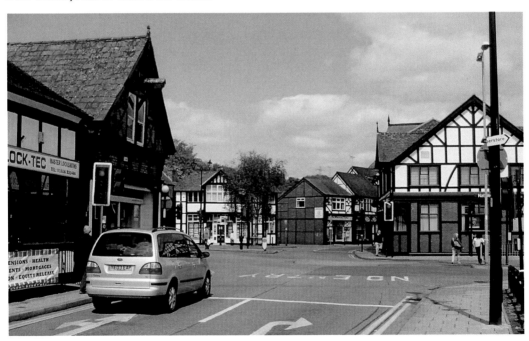

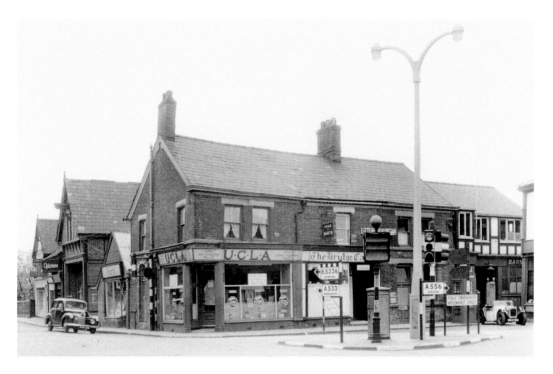

Bullring by Dane Bridge 1950s and 2009

This is an interesting photo taken in the 1950s; of the building at the side of the road leading from the Bullring into London Road and across the Dane Bridge. It looks nothing like the 2009 view and that is because it's not, it has been demolished, as has the small building behind it. Then the front elevation of the white building in the 2009 photo can be seen with its winch on the side. It is this building that now predominates.

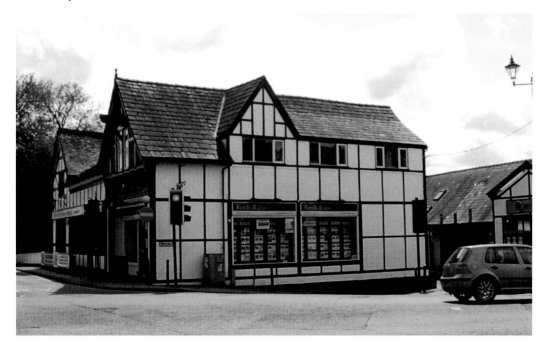

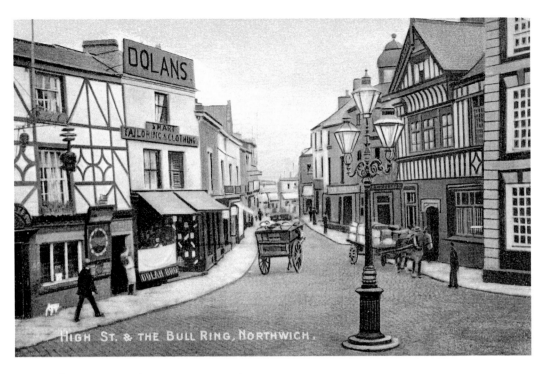

Bullring into High Street 1910 and 2009

Another photo showing the Dolans store taken in 1910, it has now been replaced by the opening to Weaver Way. There is a good view of the door to what is now the Pink Olive, which can be seen in the centre of the front elevation.

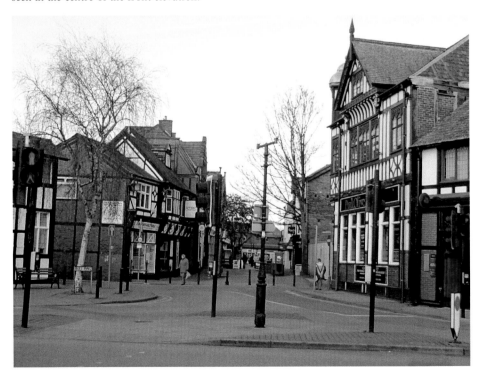

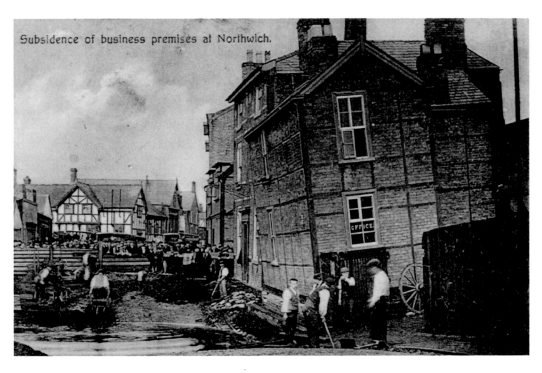

Subsidence of business premises at Northwich.

London Road Dane Bridge 1810 to 1920 and 2009

Two views of the road leading to Dane Bridge giving an example of the subsidence that the area suffered.

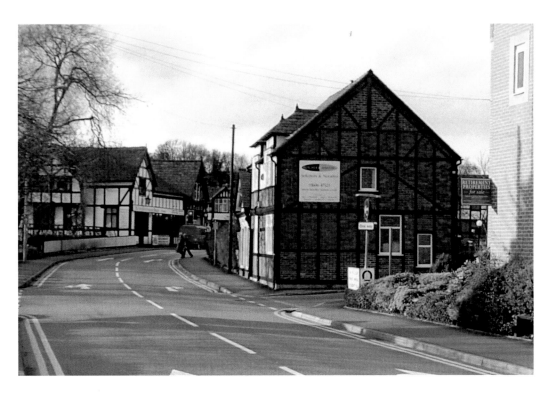

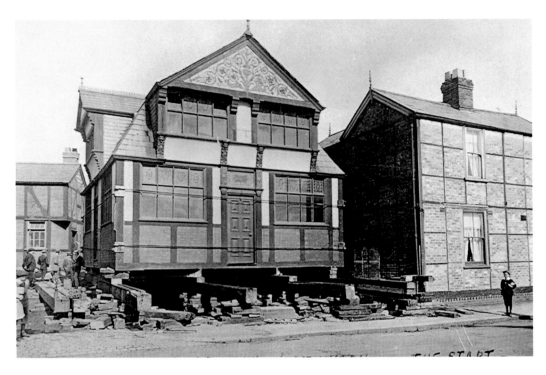

Bridge Inn 1900 and 2009

This building was famous in its time, for 'refusing' to collapse during the worst period of subsidence and then again for being moved 180 feet on rollers from the side of the building shown to the rear of it. It was a pub from 1869 to 1912 and is now an office building as can be seen in the modern view.

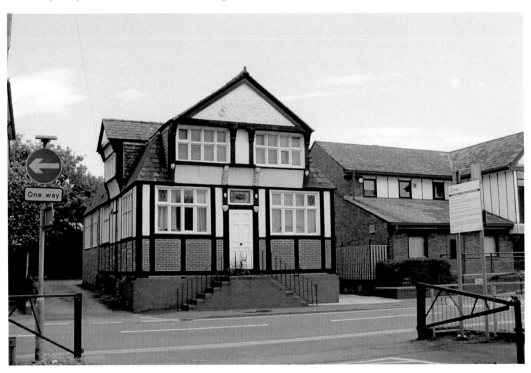

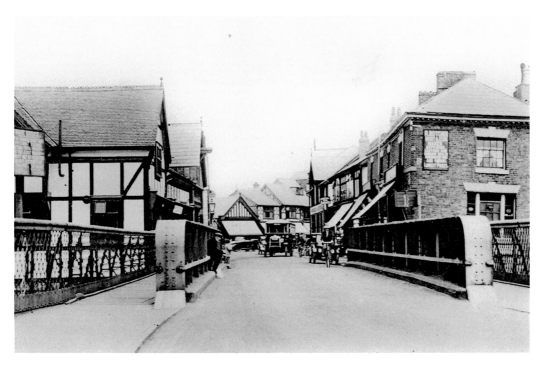

Another view of Dane Bridge

Another view of the road leading to Dane Bridge showing the changes over the period.

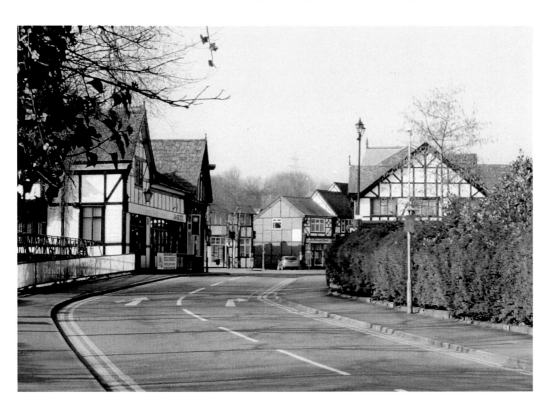

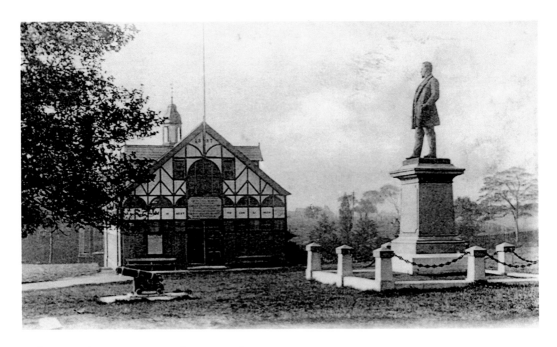

Robert Verdin statue around 1910 and 2009

Leaving the town centre for a while we travel up to the Verdin statue in nearby Verdin Park which was paid for by public subscription. A renowned local benefactor and dominant figure in the salt industry Robert Verdin provided, amongst many other things, the park and swimming baths. He served for little over a year as Liberal MP but died on July 27 1887 aged 50. The cannon at the foot of the statue was there for many years.

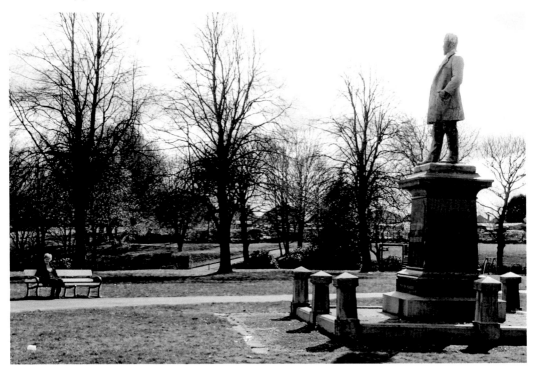

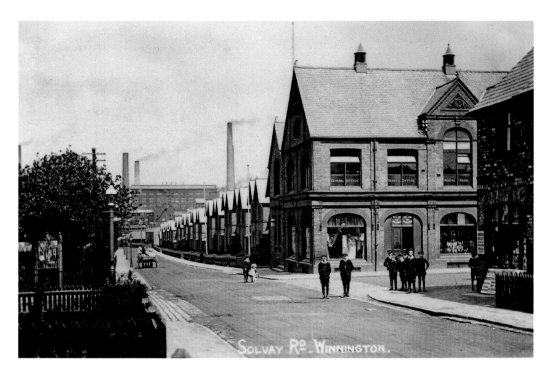

Solvay Road 1890s and 2009

Continuing to the Winnington area and Solvay Road, the old picture above is filled with period charm but look at the modern one dated 2009 below, surely less the big building in the foreground they look the same? But no, all of these houses have been demolished to make way for an extension to the Brunner Mond works.

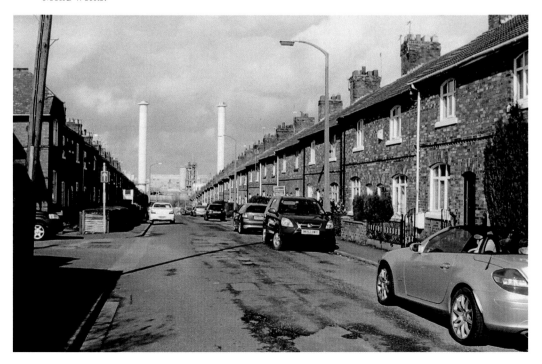

Solvay Road 2009 and ICI workers 1950s

Look at the bricked up arch window on the left – then match it with the top right in the old photo on page 37. Over the road is where the row of terraced houses in the old photo started together with the large building which was the Winnington Co-operative Store. The demolished houses were called Fire Houses as they were provided for the works fire brigade workers. A group of ICI workers are seen during a break.

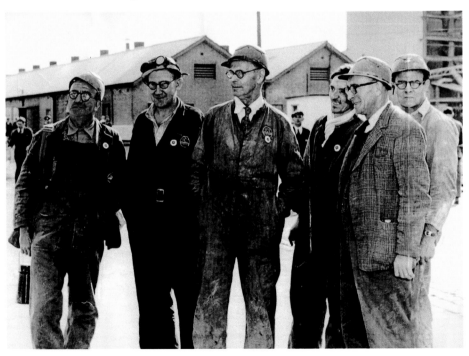

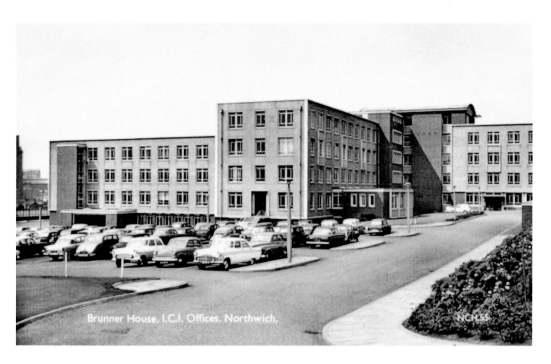

Brunner House, I.C.I. Offices, Northwich.

Brunner House 1960s and 2009

This along with the vast expansion of the ICI rail system in the 1950s must rank as one of the biggest money wasting exercises in the history of Northwich. This extensive office complex was officially opened on the 15th January 1960 by Sir Alexander Fleck. By 2002 it had been replaced by a private housing estate as shown in the 2009 photo.

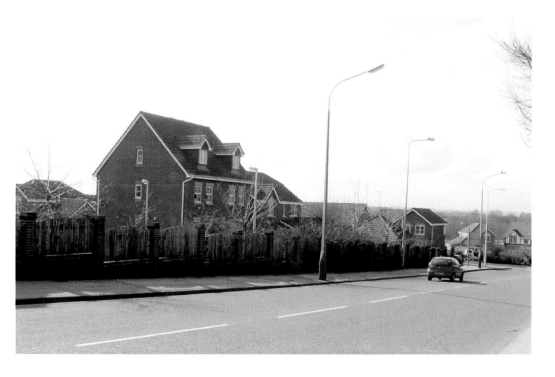

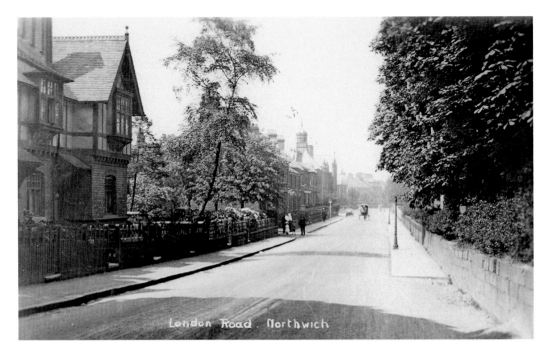

London Road 1923 and 2009

This road leading into town was photographed in 1923 and shows a horse drawn trap and a family on the footpath. In the distance can be seen the Verdin Technical schools and Gymnasium. Once a very busy road it has now been by-passed.

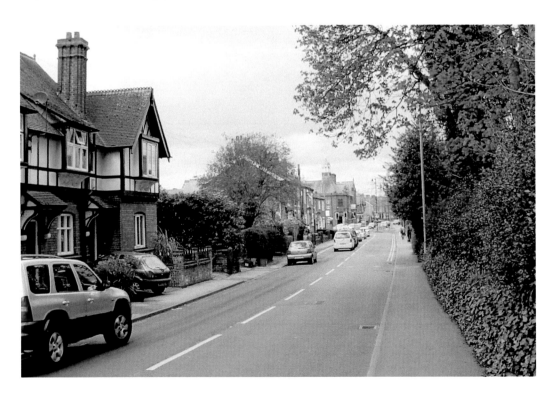

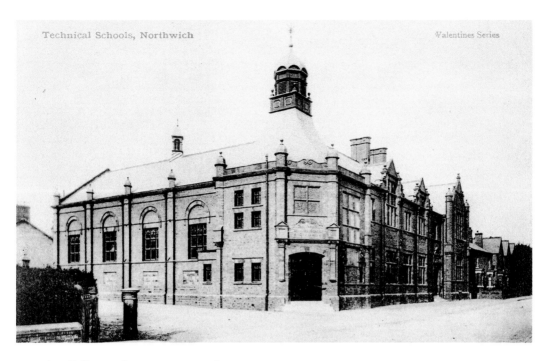

Art College 1897 to 1910 and 2009

The Verdin Technical schools and Gymnasium in London Road were built by Sir Joseph Verdin at a cost of £12,000. It was opened on July 24th 1897 by the Dowager Duchess of Westminster. It later came under the wing of the new Mid Cheshire College of Further education and received the less expansive title of The Art College, London Road. Scaffolding covers the building in the modern shot.

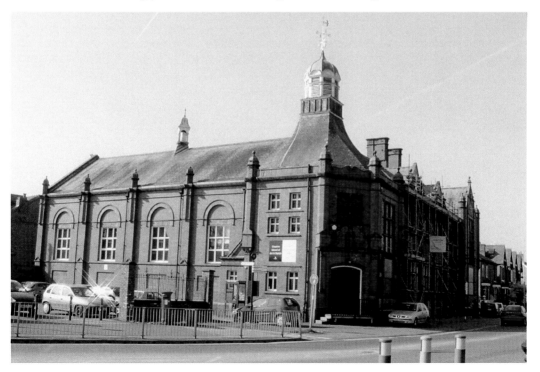

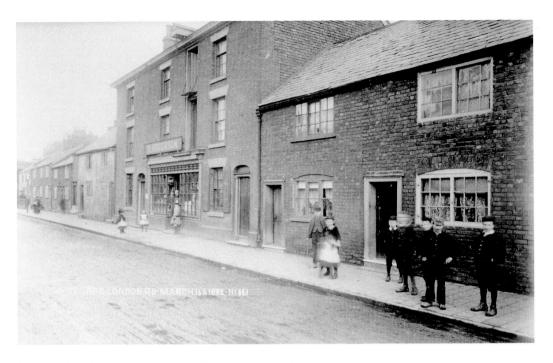

London Road by the Arches 16 March 1892 and 2009

Further down London Road and just before the arches carrying the Cheshire Lines railway we come to a row of houses. In the early photo dating from 16th March 1892 there is a large warehouse with the name S. Rogerson and a grocer's shop owned by Henry Stubbs. In the modern photo it still stands and has been converted into dwellings. Albeit that the front elevation has been altered somewhat and the winch removed.

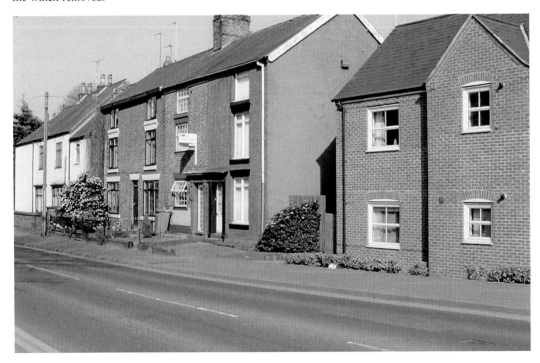

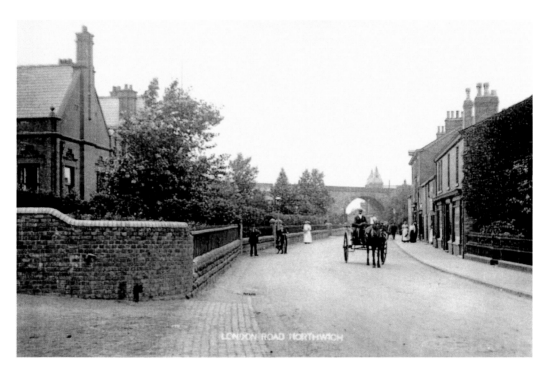

London Road 1892 and 1910

Another photograph of the same location showing a man on a pony and trap, this road, leading into Northwich is now extremely busy. The old workhouse, now the Salt Museum, can be seen on the far left.

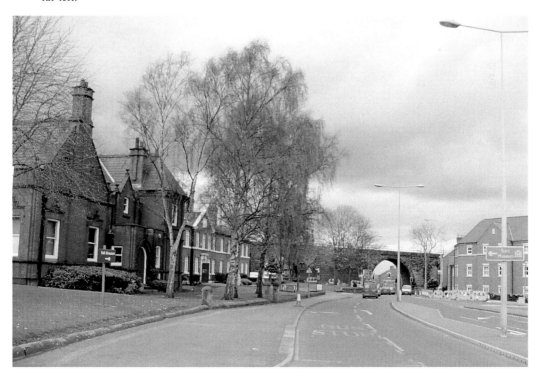

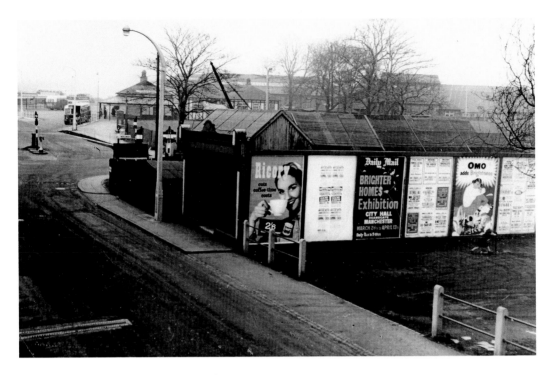

Northwich Bus Terminus 1955 and 2009

In 1924 the Mid Cheshire Motor Bus Company was taken over by the North Western Road Car Company with offices in London Road, the buses leaving from Brockhurst Street and the Bullring. It would be sometime before a custom built terminus would be opened nearby; this can be seen in the 1955 shot. The site is now a supermarket and a small row of bus stops are in Watling Street.

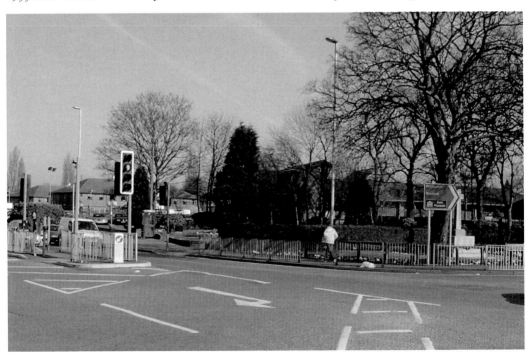

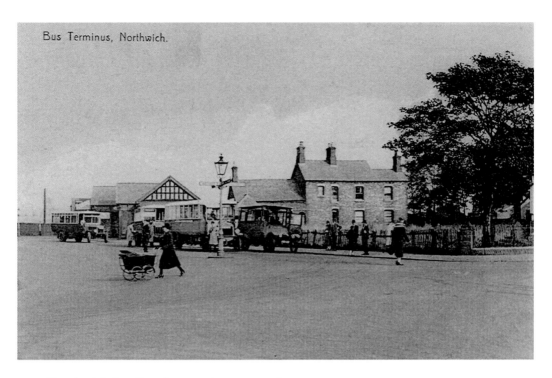

Northwich Bus Terminus early 1920s and 1930s

The early photo shows the Northwich Bus Terminus at the junction of Brockhurst Street and London Road in the 1920s. At the junction you will see a disused graveyard and war memorial commemorating WW1 but the small graveyard is on the map of 1900 as abandoned. In the modern photo overleaf the memorial is still there but the gravestones have been placed around the edge and the area landscaped.

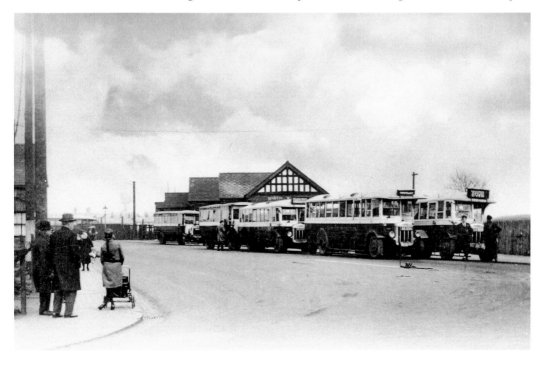

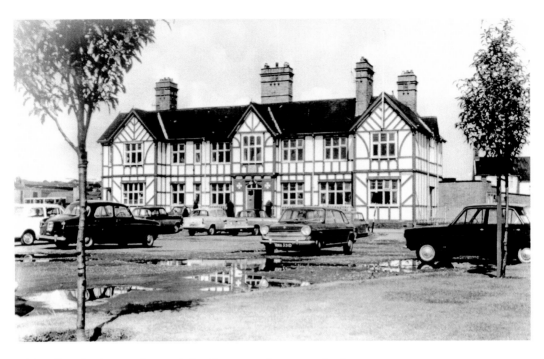

Old Police Station 1960s and the Court on the same site in 2009

The original home of law and order in Northwich was The Lock Up at the junction of Cross Street and Church Street off the Bullring. This suffered from the effects of subsidence in the late 1800s and was transferred first to Leicester Street and when completed, the black and white building shown in this 1960s photo. This building was demolished in 1967 and the staff transferred to the newly built HQ across the road. The court building shown in the new photo was then built on the site facing the other way.

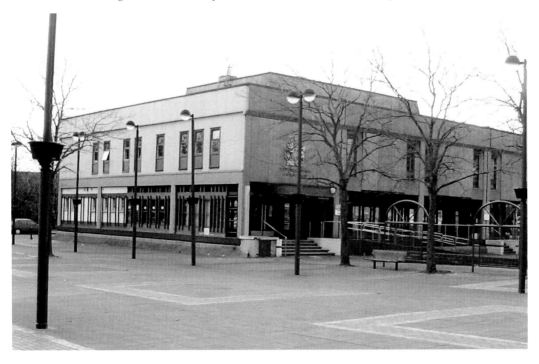

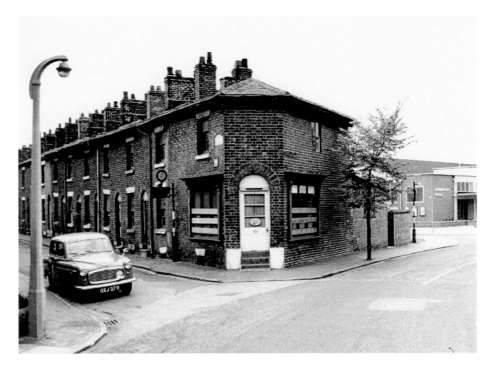

Memorial Hall 1950s and 2009

This 1950s photograph is of a Hillman Minx parked at the end of John Street, which is over the road from the Northwich Memorial Hall. Once the centre of an area of a tightly packed terraced streets this one and those around it would soon be re-developed. The 2009 photograph shows the area today, where the Hillman was parked is now just within the bounds of Northwich Police Headquarters and the street has become part of the dual carriageway.

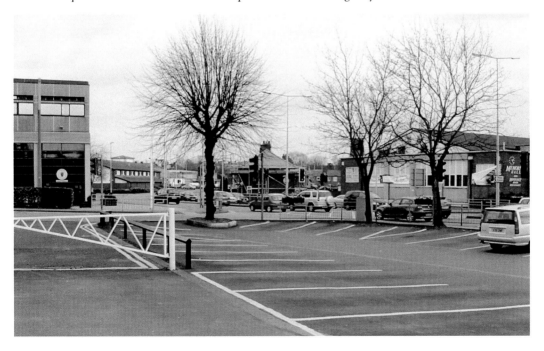

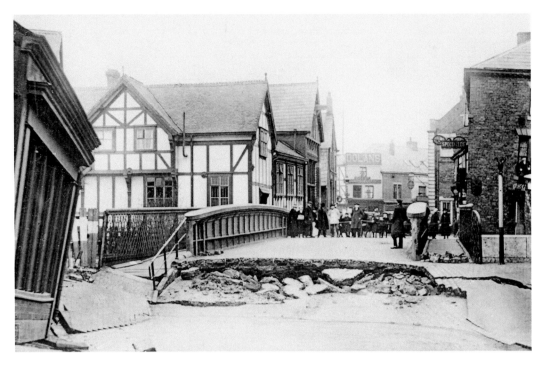

Dane Bridge 1900 and 2009
Here we take one last look at the devastation caused in the Dane Bridge area.

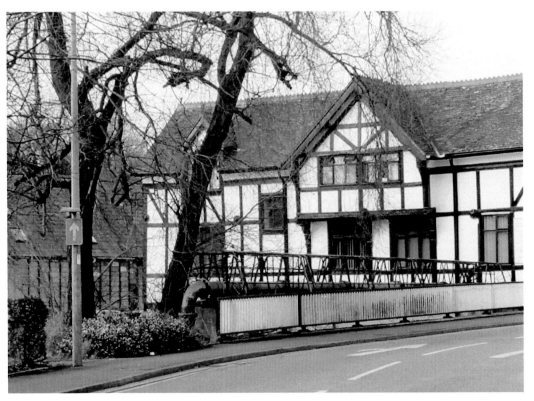

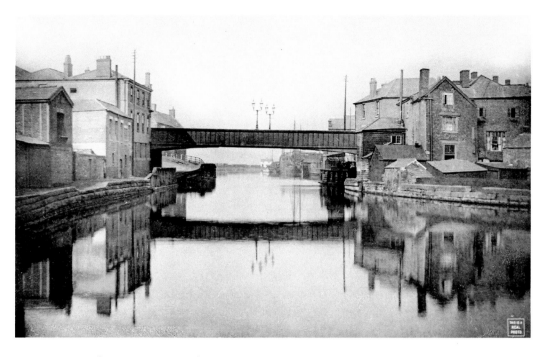

Town Bridge pre-1899 and 2009

The bridge shown in the old photo replaced an older stone one in 1858. By the end of the century subsidence had arrived with a vengeance and the bridge was sinking to a point where boats could not get under it! It was decided to build another using a new method whereby the bridge would sit upon a floating pontoon in the river. The result is the one shown in the 2009 photograph.

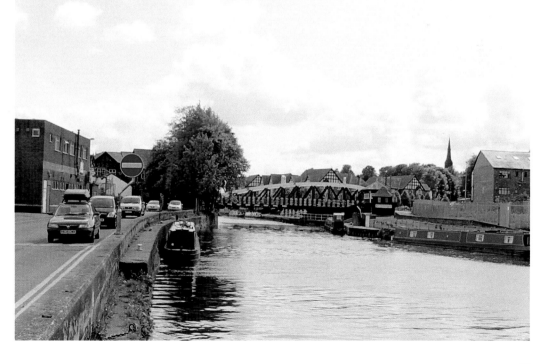

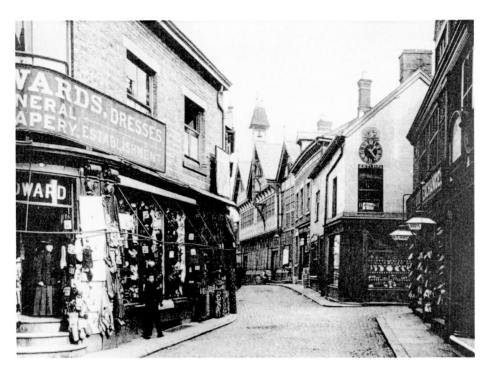

Market Street 1891 and 2009

In the older photo the junction with Market Street and High Street can be seen. Once leading through to assorted shops and the big market hall it now wends its way to the pedestrian precinct and the indoor and outdoor markets.

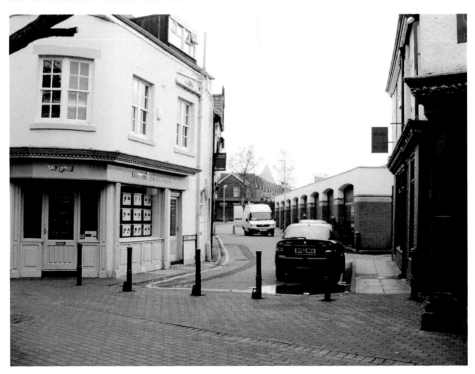

Eagle & Child 1900s and 2009

This extremely attractive building now houses the HSBC ex-Midland Bank but prior to this was a public house. An earlier building of the same name had been on the site since 1772 and this one was built in the late 1800s. On closing its licence was transferred to the new Beech Tree public house at Barnton. The old photo shows the building under repair after subsidence.

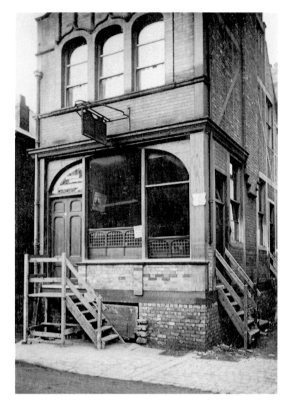

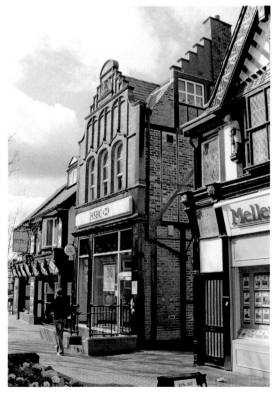

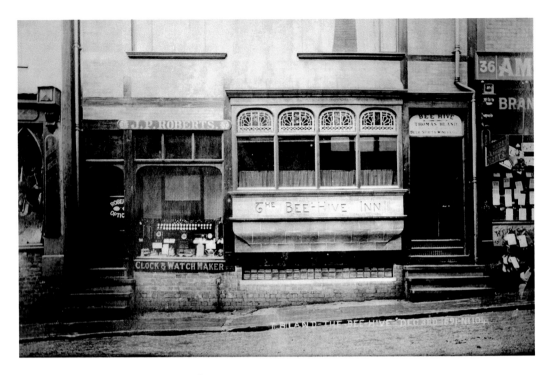

Beehive Public House 1892 and 2009

Situated in Witton Street and built in 1816, it was known as the Waterloo until 1828. It had recently been re-built when the photograph was taken in 1892. The old photograph shows six steps to the door and then in 2009 the steps have gone and the base of the front elevation is level with the footpath, the J.P. Roberts watchmakers' shop next door has been converted into a room in the pub.

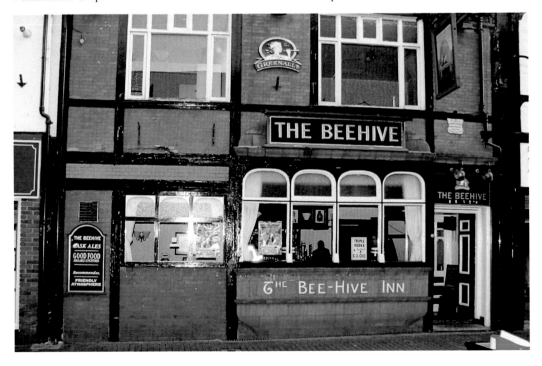

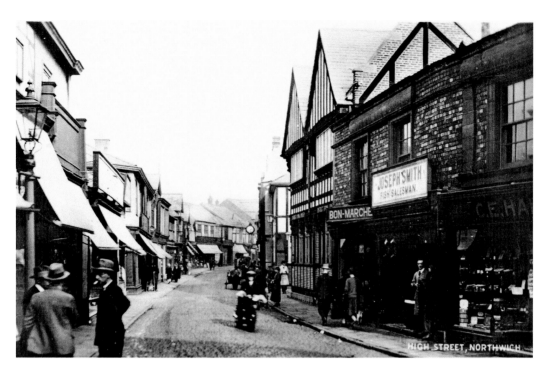

High Street 1940s and 2009

The street stretches from the Bull Ring to Witton Street. In the 1940s photograph it was a through road with Joseph Smith fishmonger and grocer at number 60, they also had premises at 180 Witton Street. By 2009 it had been pedestrianised.

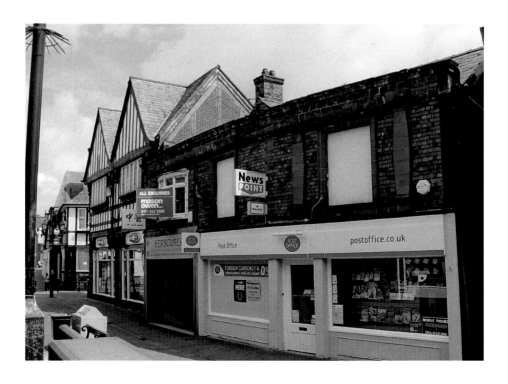

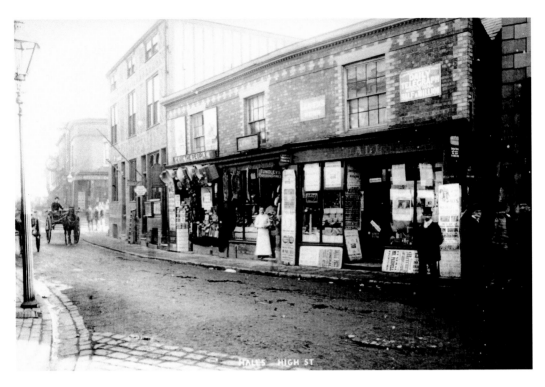

Red Lion 1890 and 1960s

In this shot we have the same view along High Street with the old buildings including the Red Lion on the corner of Crown Street. By the 1960s it was yet to be pedestrianised but has changed little since then.

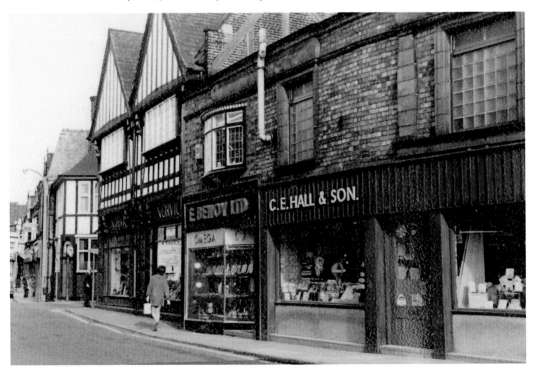

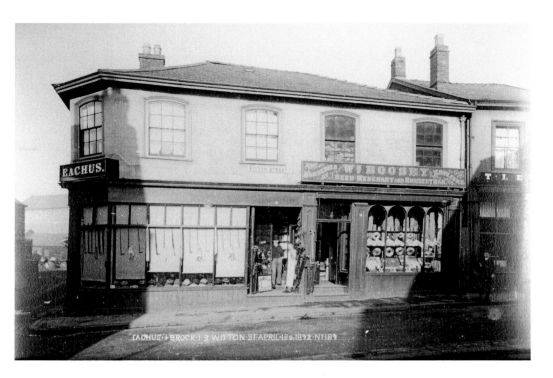

Corner Crown Street and Witton Street 1892 and 2009

Eachus's store and Boosey's gardeners' merchants were situated at 3 Witton Street, the building has now gone and been replaced with a modern one and is currently a jewellers. Eachus Bros photographic shop moved to the new precinct during re-development. Moore and Brocks at Barons Quay can be seen at the end of Crown Street.

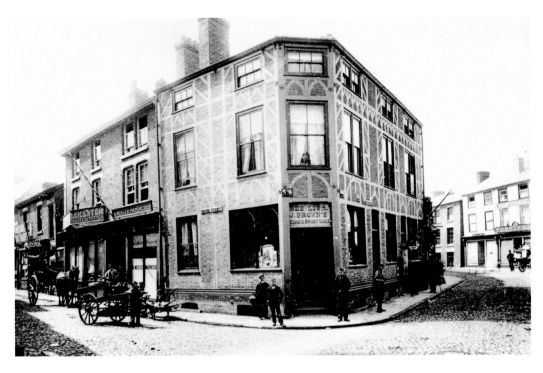

Junction Crown Street High Street. Red Lion 1892 and 2009

The Red Lion pub at the corner of Crown Street from the opposite direction, this building still stands as a Travel Agent. The front corner has however been drastically altered into the black and white Northwich style. The side of the building in Crown Street remains unchanged as you can see in the 2009 photo.

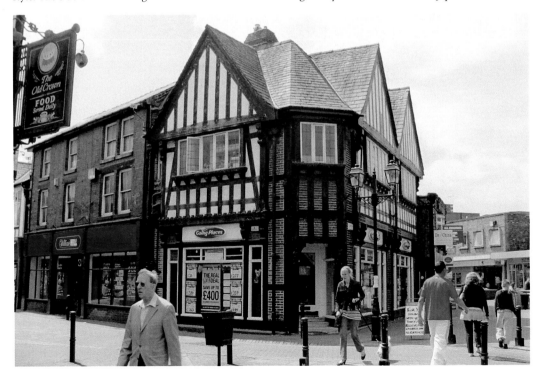

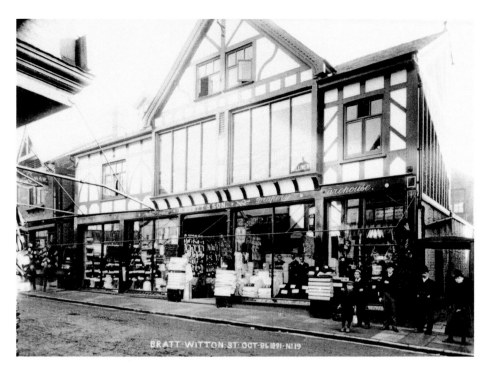

Bratt Witton Street 1891 and 2009

These two photographs show the completed transformation from the old Bratt's store over the years. This is the forerunner of the well-known Northwich department store in Witton Street. The original frontage shown in this photo has changed but the store is still in the same location. This shows the Bratt shop on the 8th October 1891.

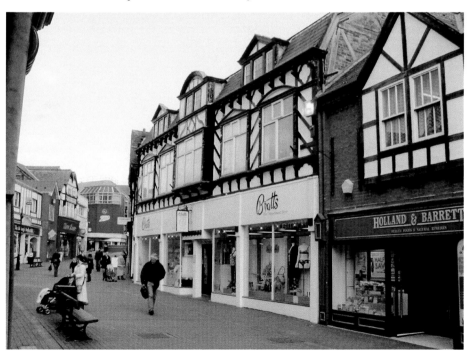

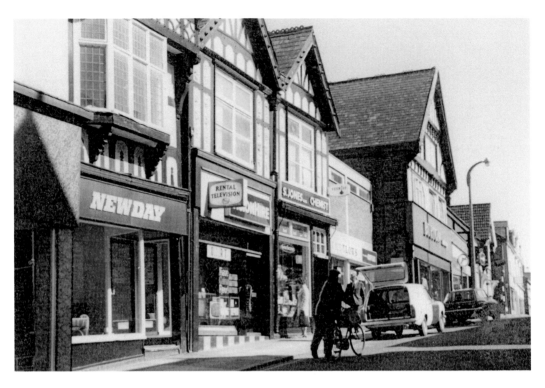

Witton Street Burtons 1960s and 2009
We turn around and walk up Witton Street, the big Boots store is in place of three smaller ones in the same building, and Burtons is still there albeit with a face change.

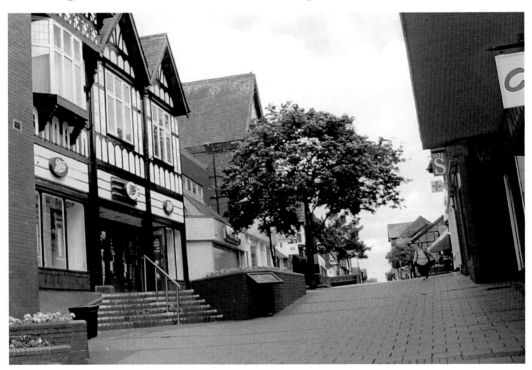

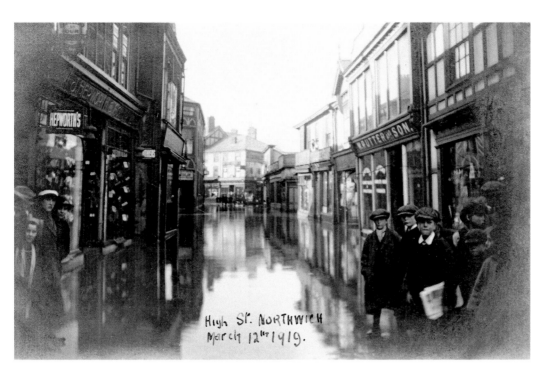

High St. NORTHWICH March 12th 1919.

Witton Street during the 1919 flood and in 2009

As well as subsidence Northwich suffered many serious floods and this is one such in the lower Witton Street area during 1919. We are looking towards the Red Lion at the junction with Crown Street. The modern photo is taken from slightly further back to enhance the vista.

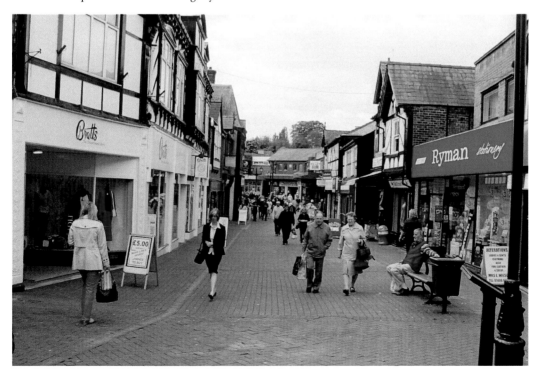

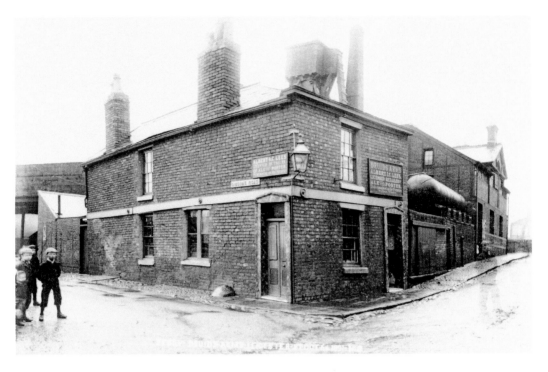

Leicester Street 1891 and 2009

The Druids Arms at the junction of Leicester Street and Gibson's Road, an area of timber yards, industrial premises and poverty at the turn of the last century. The pub was built in 1840-44. Next to it was the Leicester Street mine and the pub subsided badly and was demolished around 1909. The whole area has now been re-developed and houses the Marks and Spencer store and the now famous Northwich Motorcycle Thundersprint.

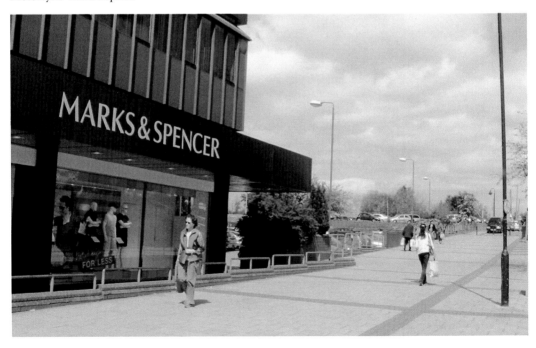

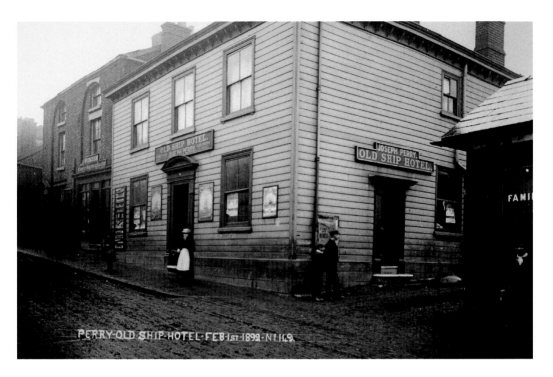

The Old Ship Hotel in the 1920s and 2009

The old photo shows the inn during the 1920s but a pub had been on this site since 1763. This one, clad in weather board to look like a ship, was demolished in 1933. It stood on the corner opposite Leicester Street and the path at the side now leads into the shopping precinct. Marks and Spencer took its place on the site and it is now a Clinton Card shop.

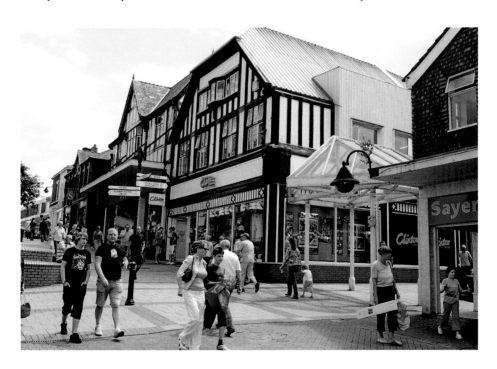

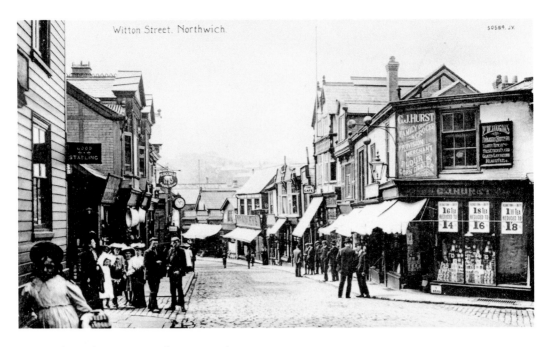

Witton Street around 1900 and 2009

The view is of mid-Witton Street, the flat roofed building of G.Hurst provision merchants on the right being at the Leicester Street junction. It is still there and houses a Phones 4U store. The boarded building in the left foreground is the aforementioned Old Ship Inn. Despite the upheaval due to subsidence many buildings are still there.

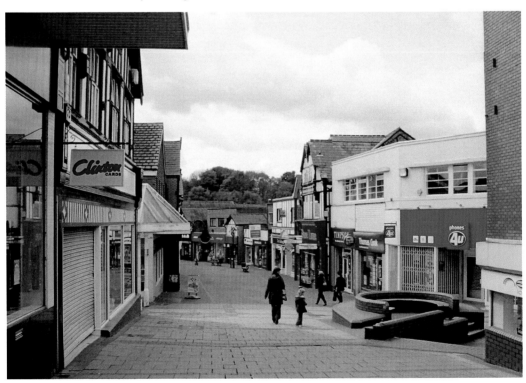

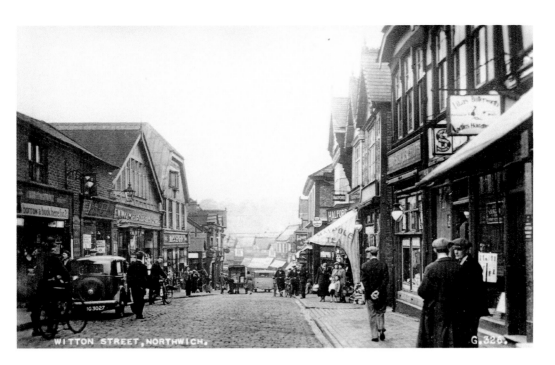

Down Witton Street 1930s and 2009

No view would be complete without a photo of F.W.Woolworths, this shop in Witton Street is the one where I bought my Christmas presents as a child, as I am sure did a lot of children. The Ship Inn has been replaced with Marks and Spencer on the corner. In the modern photo we see that Woolworths is still there – but has closed! It was one of the first companies to succumb to the 2008 depression.

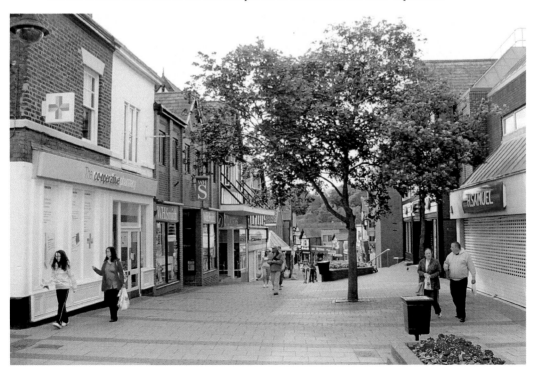

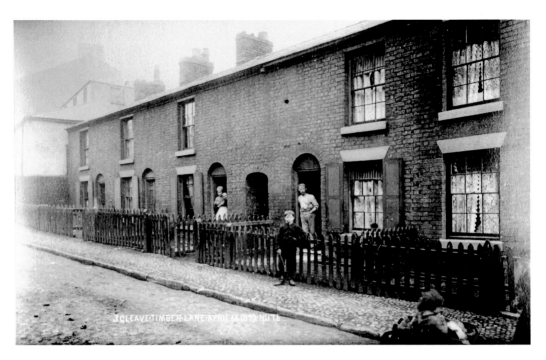

Timber Lane 1892 and 2009

Timber Lane looking towards Witton Street. In the opposite direction it once led through to an area of courts and terraced houses. Past Timber Lane school, John Street and New Street to the river Dane. Now it leads to the police station, the rear of the shops and Chester Way.

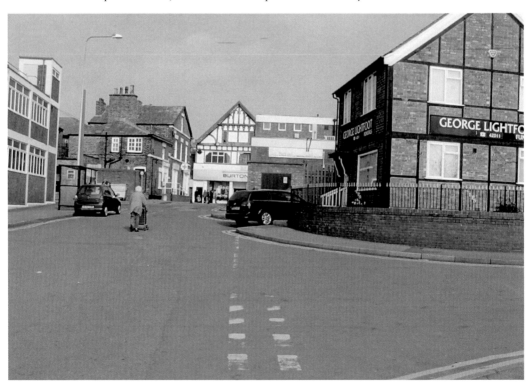

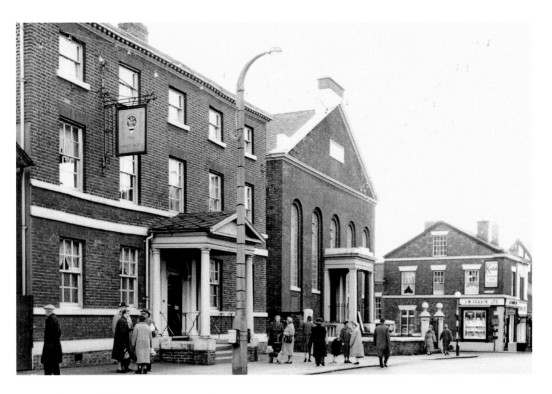

Witton to Timber Lane 1950s and 2009

The older photograph was taken during the 1950s, possibly in view of the fairy lights, at the time of the queen's coronation. The large Talbot Hotel was opened in 1831 and the Central Methodist Chapel next door was built in 1854, both would soon be swept away to make way for – the building in the modern photo! I'm sure that these alterations enhanced the aesthetic view of Witton Street!

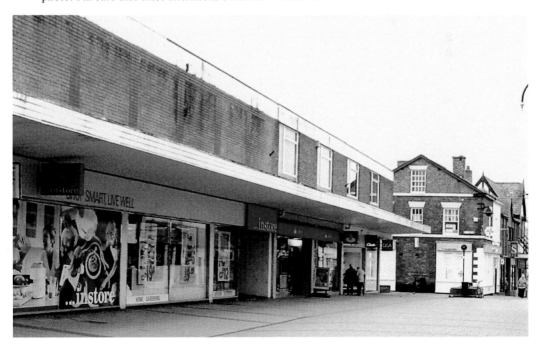

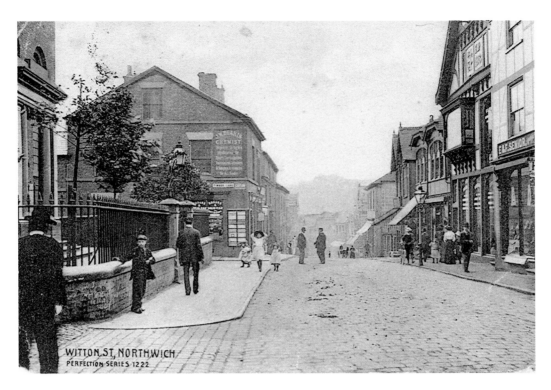

Witton Street 1890s and 2009

Another view of the area, this time from a photograph taken during the dying days of the nineteenth century. The iron railings from the church wall have not yet gone to help the war effort and the now buried stone setts collect the droppings from the many horses that use the road.

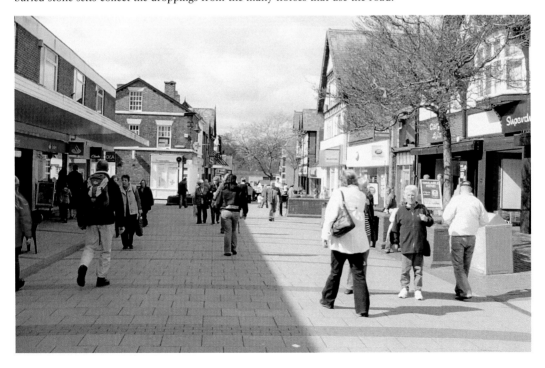

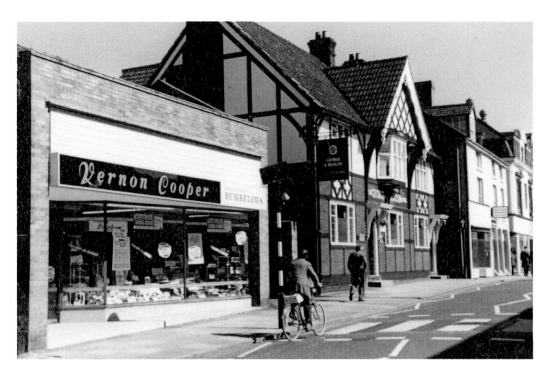

Witton Street George & Dragon 1960s and 2009

Passing Boots and Burtons we come to Vernon Cooper and the George & Dragon pub. The George & Dragon was sold in 1828 for £640; it had stables, workshops, 3 dwelling houses, a schoolroom, gardens and a bowling green! In 1928 it was demolished and rebuilt as a black and white half-timbered building but in 1993 it closed as a pub. In the modern photo it is a Curry's and Superdrug store, Vernon Cooper is now Boot's opticians.

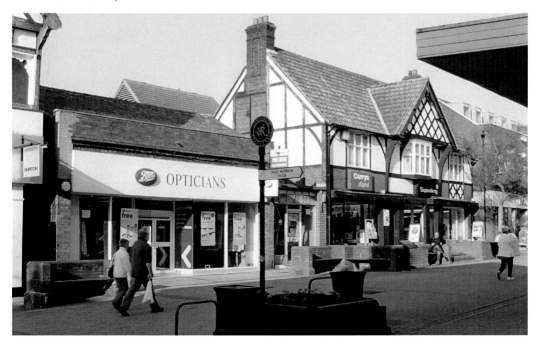

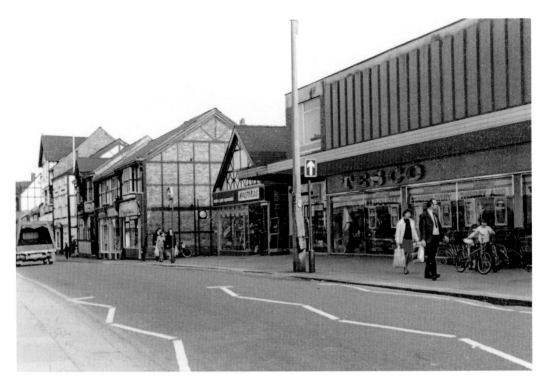

Tesco's Witton Street 60s and 2009

It is the 1960s and the attractive red brick church and hotel have given way to this rather unattractive building which houses a Tesco's supermarket. By 2009 Tesco's has gone and the building houses Abbey National, a discount store and shoe shop.

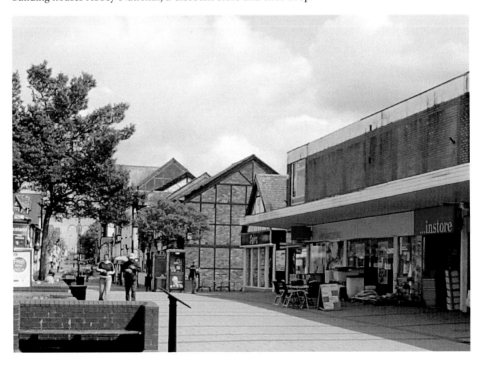

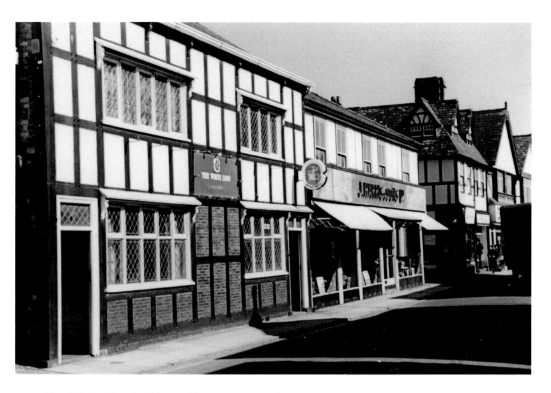

The White Lion in Witton Street 1970s and 2009

There is a hole where once stood the White Lion opposite the RAOB Club, it was once thought that the pub had sunk into the ground from three storeys to two but this was later found to be incorrect. This building was built in the last century and closed several years ago, demolished and left as a hole!

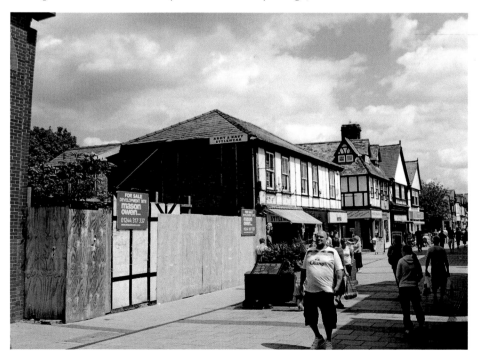

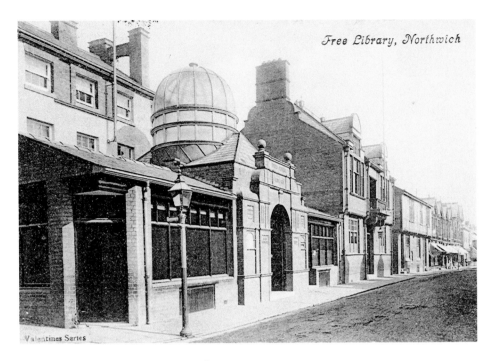

Free Library, Northwich

Valentines Series

Library 1890s, 1920s, 1970s and 2009

In 1887 Sir John Brunner presented the library in the first photo to the town. By the turn of the century it had become unserviceable through subsidence. In 1909 the second library was built. By 1915 cars had arrived in the shape of this Model T Ford, made in Manchester I believe. By the 1970s the ubiquitous Vauxhall Viva can be seen.

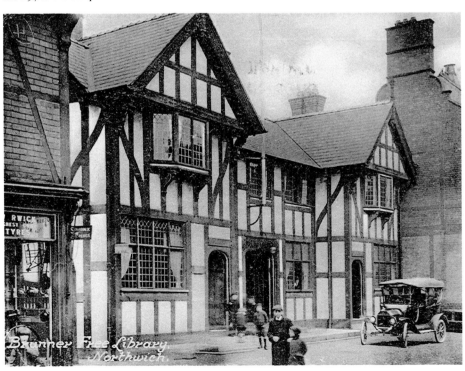

Brunner Free Library, Northwich.

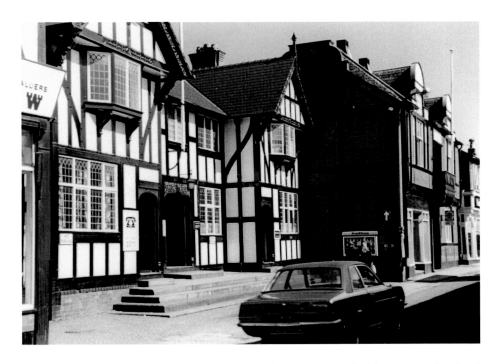

The library housed the Salt Museum until 1981 when a Victorian building on London Road (previously Northwich Workhouse) was restored and became the new Museum. Besides the story of salt, the museum also tells the wider history of the area and has special exhibitions and events throughout the year.

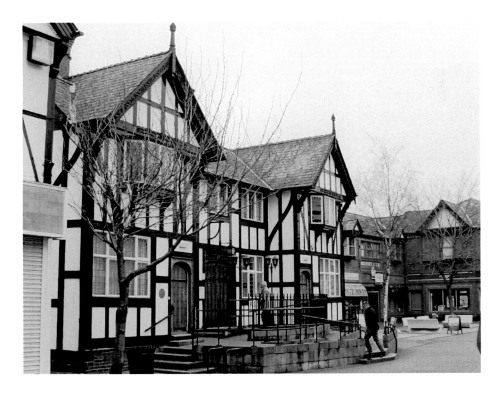

Salvation Army 1920 and 2009

The Salvation Army headquarters was and still is in nearby Tabley Street but careful detective work shows that this photograph was taken in the very pleasant garden at the rear of the library. You can see in the 2009 photograph that garden is still there, if dwarfed by the nearby Sainsbury's car park.

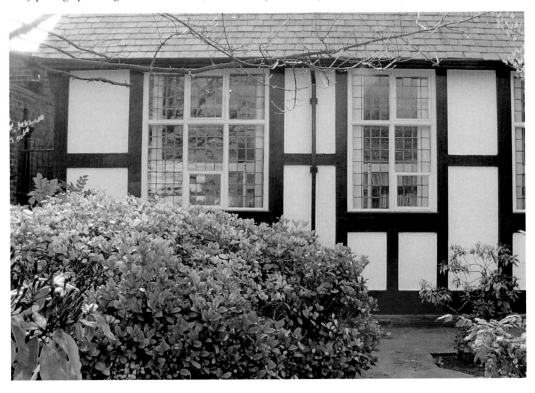

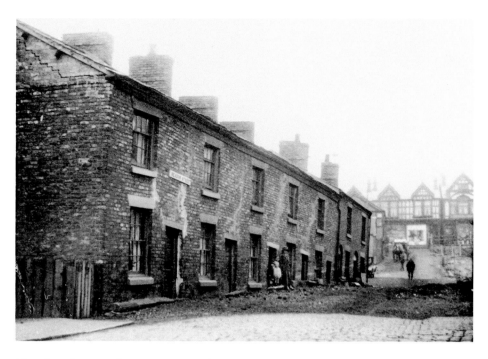

Meadow Street 1890 to 1910 and 2009

Meadow Street leading from Witton Street was at one time one of a large number of streets and courts in this area that was decimated by subsidence. The poorest of the population lived here and in the Leicester Street area. In the old photo subsidence has taken effect – but people were still living there. The modern shot shows the street today.

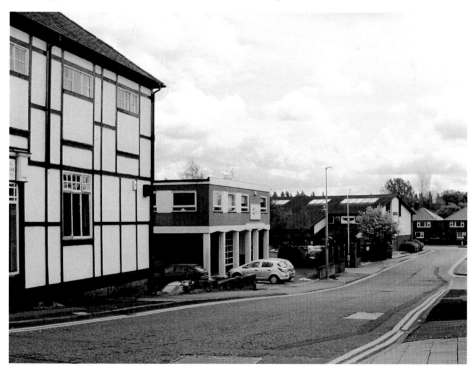

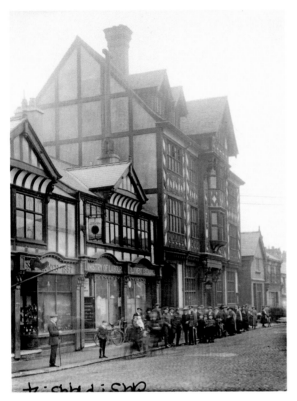

The Post Office, 1930 and 2009

As we suffer another major depression it's timely to see a photo of the Great Depression which lasted from 1929 onwards to the war! This photo has been marked as 'soldiers guarding people at the Labour Exchange'. I think it more likely that they are amongst those queuing as they are standing around in uniform, some smoking. The Labour Exchange is next to the post office.

The post office building now houses the Penny Black, a Weatherspoon's pub.

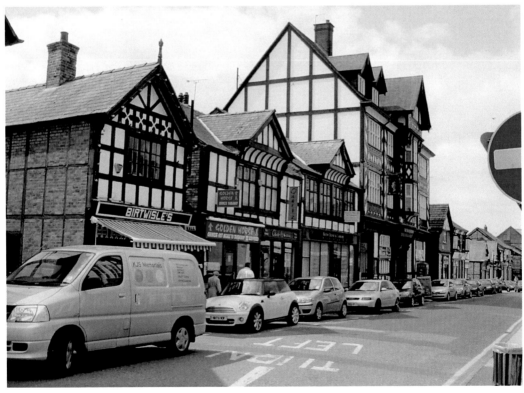

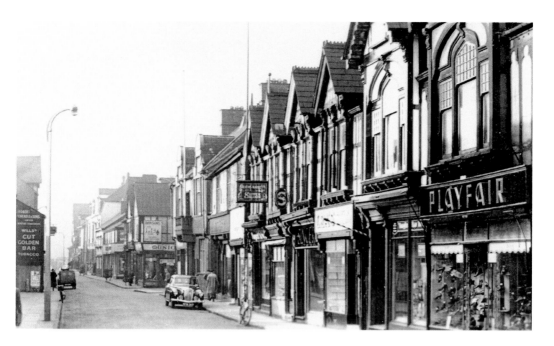

Witton Street 1950s and 2009

Now we have just passed the library on the right, Dawson's music shop can be seen; schooldays in the swinging sixties made the shop a mecca for wannabe rock singers. And you could buy the *Record Mirror* for a penny, much cheaper than the *New Musical Express*! Over the road is Cheadle's tobacconist with the smells of tobacco products from around the world. The gable end advertises cigarettes and tobaccos and you can still see the old adverts there now!

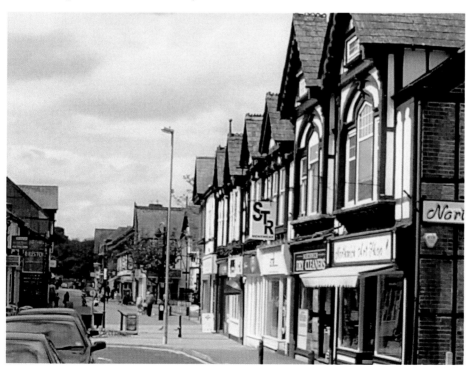

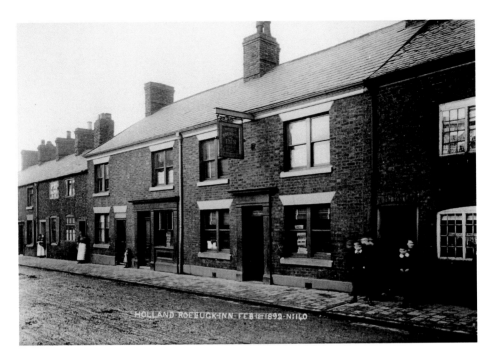

The Roebuck 1892 and 2009

Situated opposite St Wilfred's church the Roebuck can trace licensees from 1772 to the present and is the second oldest inn in Northwich, the oldest being the Bowling Green in London Road. Some say that The Roebuck was built in 1700 although it can be traced only as far as 1772 as licensed premises.

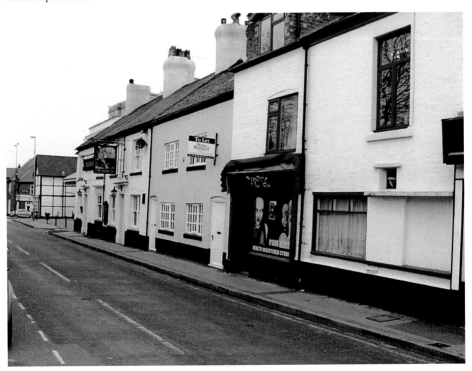

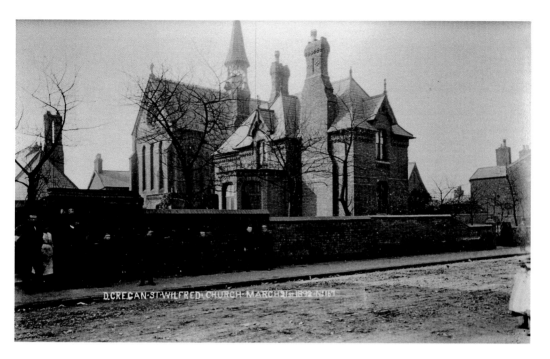

St Wilfred's Church 21 March 1892 and 2009

Built in 1856 at a cost of £4,000 including the school, the marble altar is a copy of the altar in Bruges Cathedral. The church was extended in 1901-2 at a cost of £1,000. The priest's house has undergone change and is an almost complete re-build of the original.

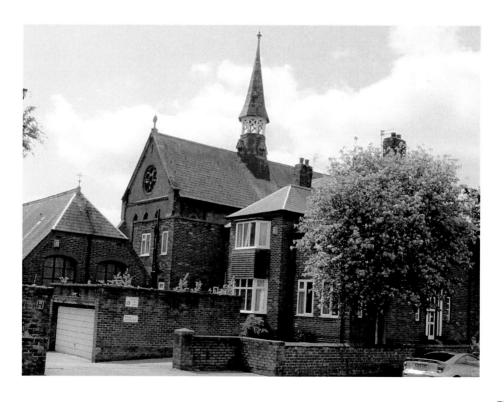

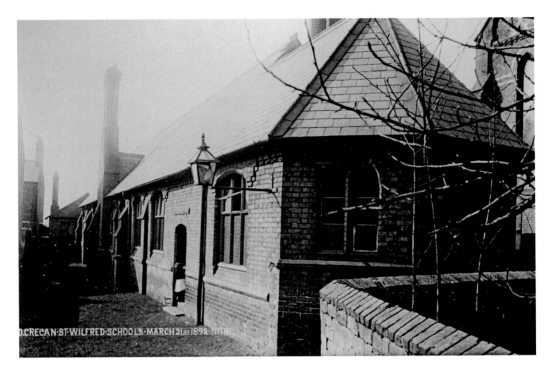

St Wilfred's School 21st March 1892 and 2009

This school building built in 1856 is now the parish centre. The school became too small for the growing population and in the 1950s had classrooms for juniors and the school canteen in Church Walk. Church Road was home to the sixth form. Now Catholic schools can be found at Weaverham and two, St Nicholas and St Wilfred are on the Hartford campus.

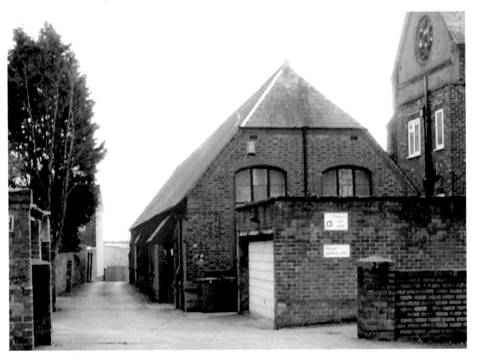

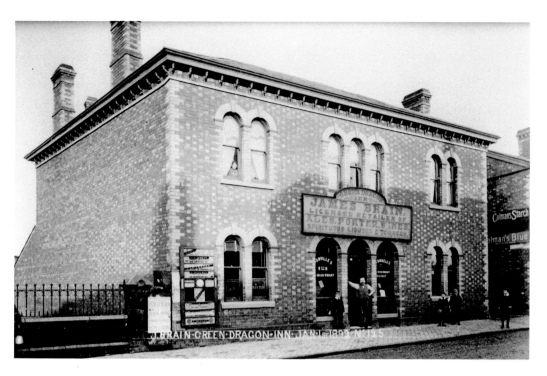

The Green Dragon 1 January 1892 and 2009

Externally the Green Dragon has not changed but the interior has been refurbished with such luxuries as a bathroom etc. The shop has been replaced with a less aesthetically pleasing building and so has the Methodist chapel. In the older shot James Brain the licensee stands in the doorway.

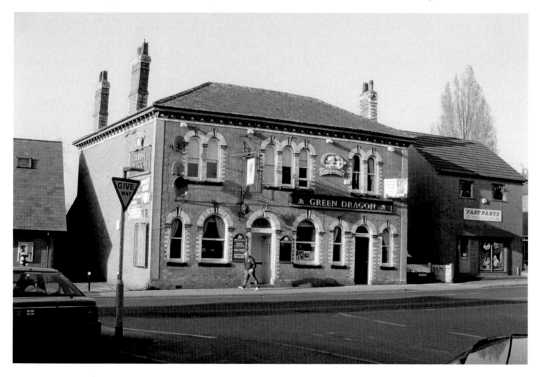

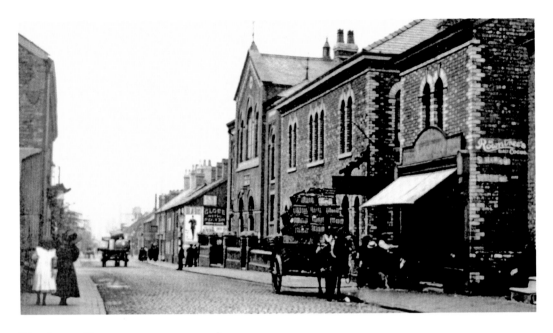

The Green Dragon 1900-1915 and 2009

This excellent view of Witton Street towards the town centre illustrates just how busy this area was at the dawn of the last century. The Green Dragon was built around 1870 in the multi coloured brick style of the period. The tall Primitive Methodist chapel and a shop that was built in the same style as the pub are on each side.

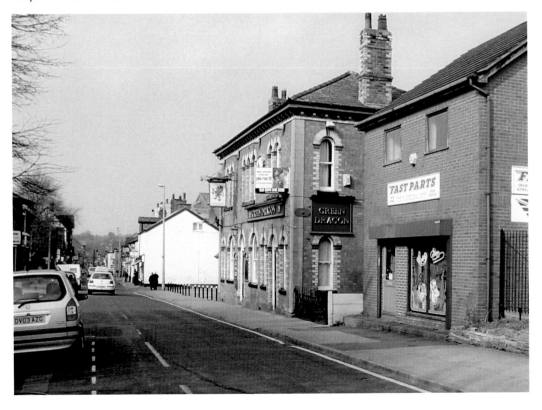

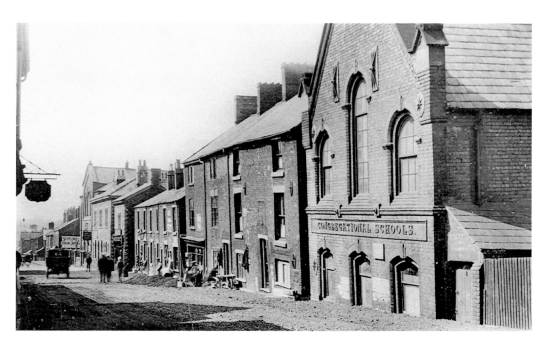

Looking down Witton Street towards the Green Dragon pub, 1892 and 2009

Views down Witton Street towards the Green Dragon pub that can be seen in the distance, the large building in the far distance is the Primitive Methodist Chapel. This stood next to the pub from 1876 to 1973 when it was re-built in the modern style. The subsiding Congregational schools can be seen on the right in the 1898 photo.

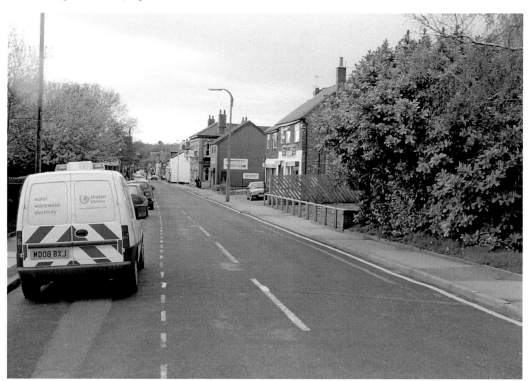

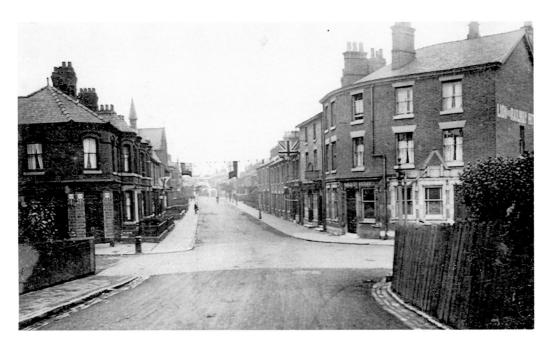

Station Road 1910-19 and 2009

The actual date of this photo is not known, I would estimate the date to be before 1920. There is a celebratory arch in the distance and bunting abounds. This could celebrate a royal wedding, the end of WW1 or simply a VIP visit. The church spire on the left is the Wesleyan Methodist chapel extant from 1881 to 1977. The 2009 photo was taken from the middle of the now busy road!

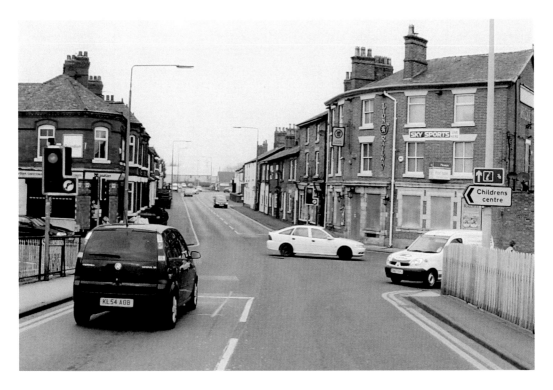

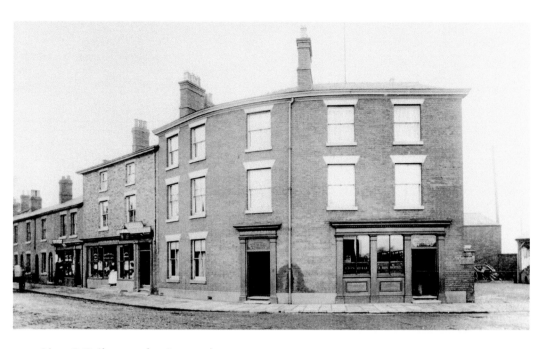

Lion & Railway pub 1891 and 2009

This large and, at the time of writing, closed pub was built in 1860 as the Lion Hotel, new stables were built in 1900 for 15 horses. Before 1958 a large upper room was used by a local undertaker as a 'chapel of rest'. The name of the first landlord was Jabez Hickson and his name can still be seen on the gable end wall.

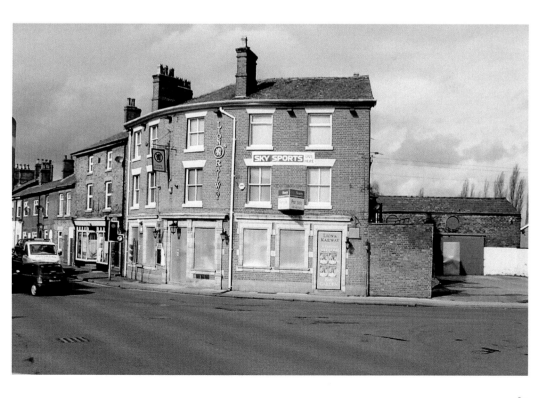

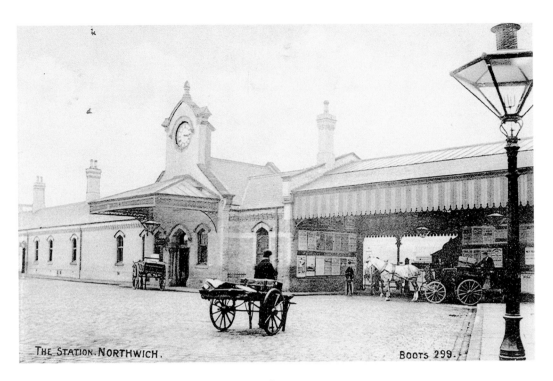

Northwich station forecourt 1900-1909 and 2009

This impressive station was built by The Cheshire Lines Committee in 1897; the line had opened from Knutsford in 1863. Later it was expanded locally with salt branch lines spreading out to the many salt mines in the area. Now a Tesco supermarket and car park cover the site of the marshalling yard.

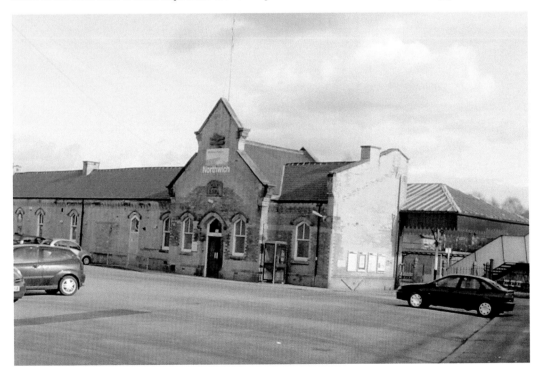

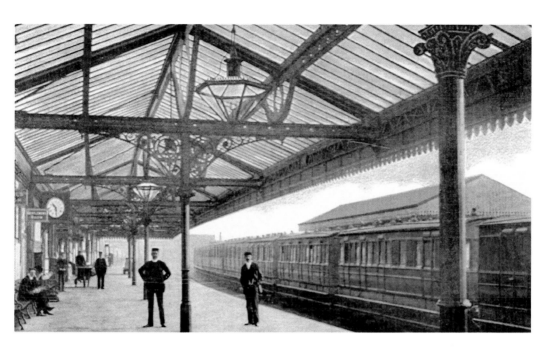

Northwich platform 1900-09 and 2009

The station platform would have been quite new in this shot at the turn of the century but has changed little over the years. Now the engine shed has made way for a housing development and the station buildings in the main have gone over to industry.

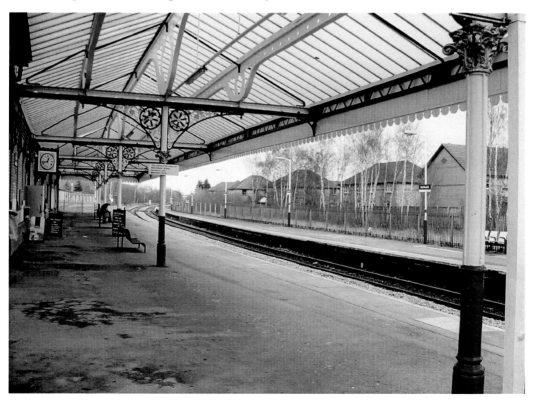

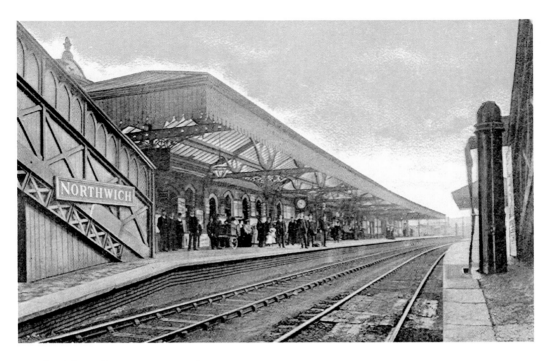

Northwich station 1910-19 and 2009

A much busier platform now as people await the Manchester bound train from this important addition to the Cheshire Lines Committee portfolio.

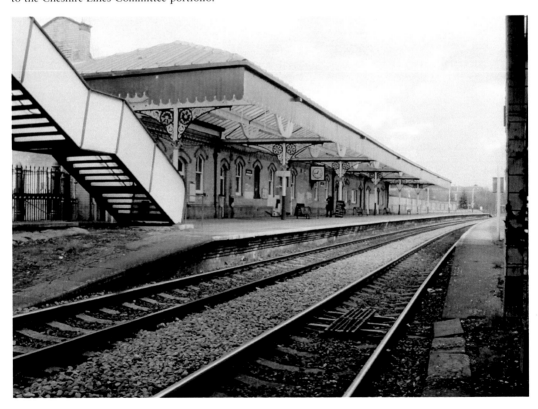

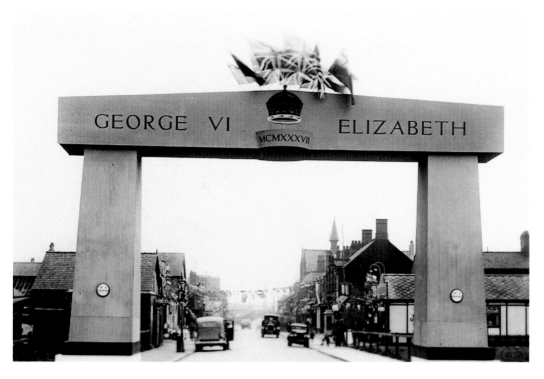

Station Road Arch 1937 and 2009

Arches were quite prevalent in the last century; salt arches were erected on Witton Brow quite often by Brunner Mond/ICI to celebrate various events in history. This arch is not made of salt but it has been erected by the ICI in Station Road looking towards the station and is to celebrate the wedding of King George the Vi and Queen Elizabeth in 1937. The buildings at the foot of the arch are still there.

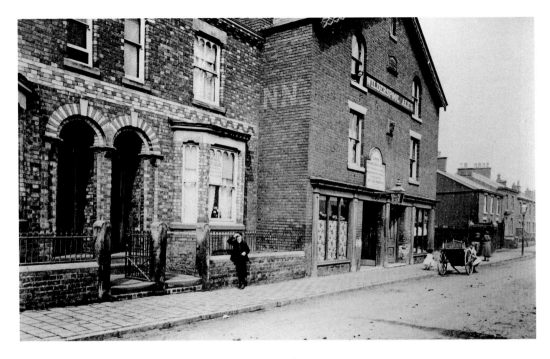

The Locomotive Inn Manchester Road 1892 and 2009

This was a public house opposite the railway station from 1869 to 1974 known as The Locomotive; the building was built as Valentine Buildings in 1864. Just past the pub, by the lamp post was the crossing for the salt branch railway line to Barons Quay. The scene of an early fatal car accident in 1908, the car owned by Mrs. Le Neve-Foster of Wilmslow didn't stop for the Flagman and was struck by a goods train being propelled by a steam engine. The result can be seen in the inset.

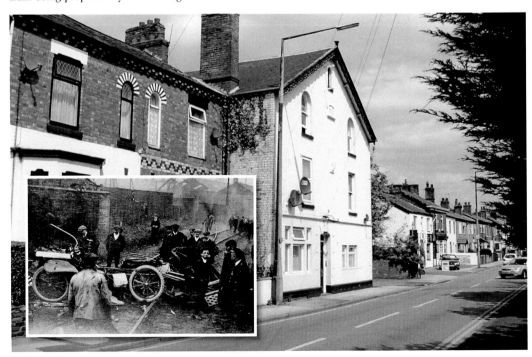

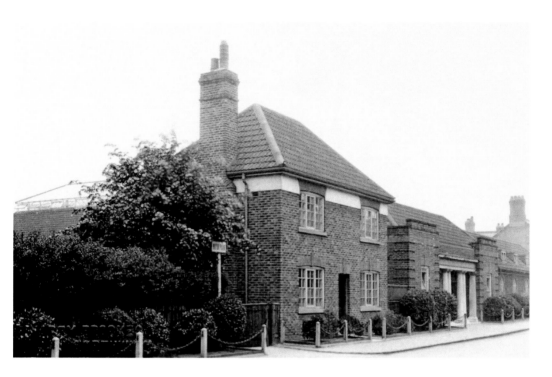

Victoria Road Baths 1920 and 2009

The main Northwich baths were built in Victoria Road in 1914, as well as a swimming pool with changing booths lining the pool there were also individual bathrooms. It remained in use until the Moss Farm complex was opened and was then demolished and the houses in the second photo built on the site.

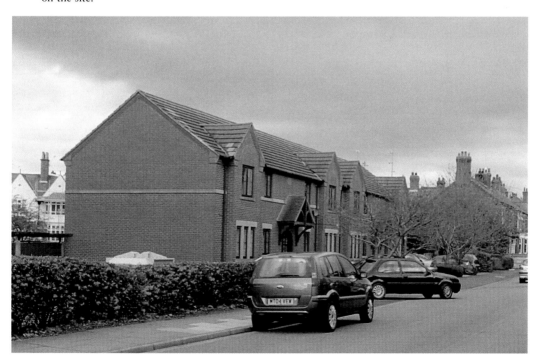

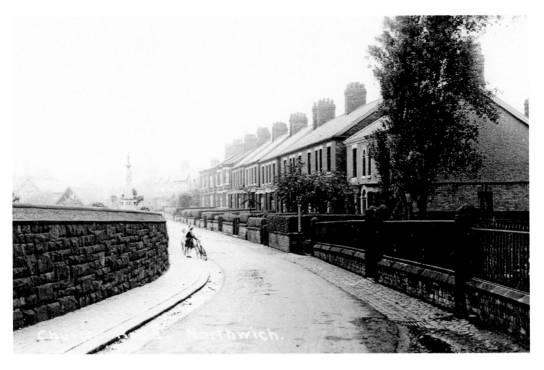

Church Road 1900-19 and 2009
This old residential area has the parish church of St Helen on one side and the houses seen in the photos on the other. It once led directly from Witton Street to Vicarage Road but the imposition of the Chester Way dual carriageway has cut it in half.

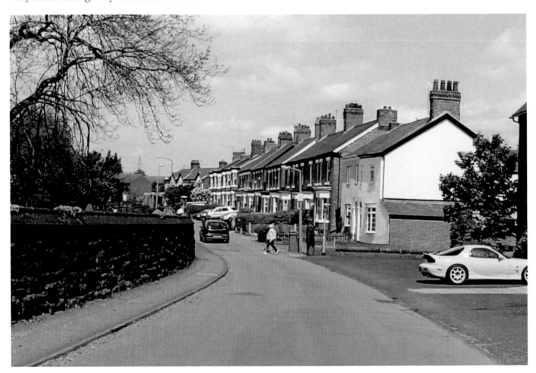

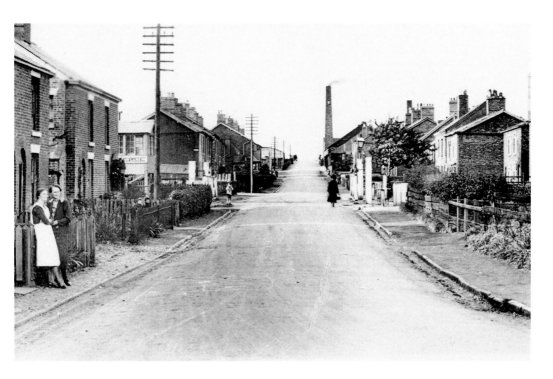

Ollershaw Lane 1900-1920 and 2009

This area bordering the huge Neuman's Flash had many salt mines and the railway lines that served them. The bridge over the canal is in the distance as is the preserved Lion Salt Works. On the left is the Salt Barge pub which was the New Inn until 1986. This road had quite a few pubs and beer houses as miners working in salt all day were thirstier than most!

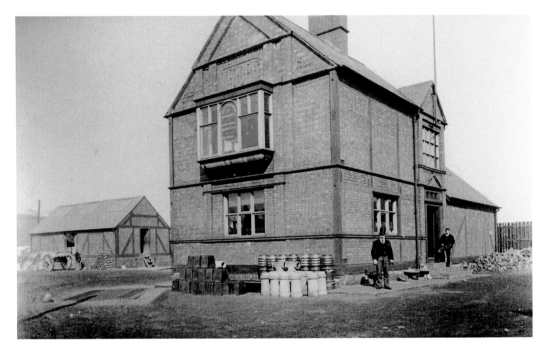

Moore & Brock Barons Quay 1892 and 2009

This area alongside the river was originally used by the Northwich Carrying Company Ltd, which was formed in 1883 by local slate merchant Thomas Moore to carry goods between Northwich and Liverpool. This name can be seen in the window and the name Moore set in the brick over the door. He was joined in 1906 by G.H. Brock and the firm Moore & Brock was founded. It was mainly a builders merchants and Barons Quay boasted its own railway line and sidings.

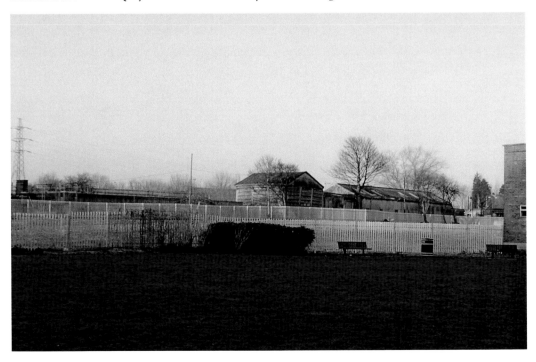

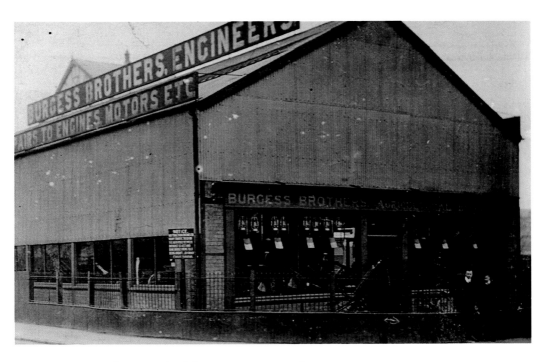

Burgess Brothers Northwich 1910 to 1920 and 2009

Burgess Brothers Ltd was an old established agricultural engineers and iron mongers located at the junction of London Road and Brockhurst Street. In the old photograph men are seen repairing the subsidence damage at the side. At the 1872 Cheshire County Show, Burgess Bros had on display a plough costing £2, a Lawnmower costing £1, a Bed for £1 and the deluxe model with "brass knobs" at £1.50!

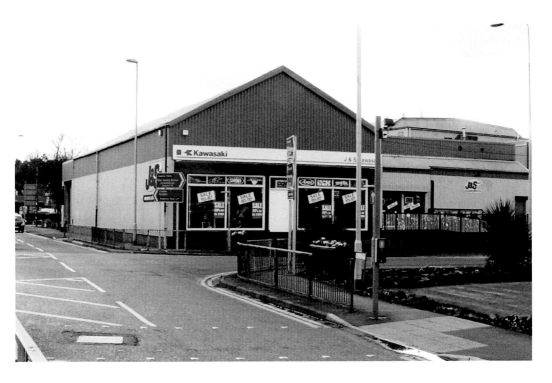

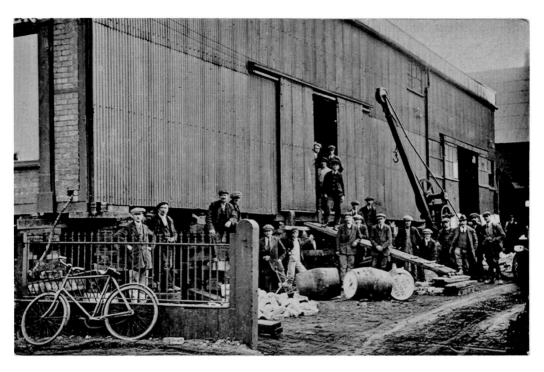

Burgess Brothers Northwich front aspect 1910 to 1920 and 2009

Another look at Burgess Brothers, this time from the front, after Burgess Brothers vacated the building it was taken over by a Kwik Save supermarket and for the past ten years J & S Motorcycle sales and spares have been located there. Next door is the Regal cinema, now closed.

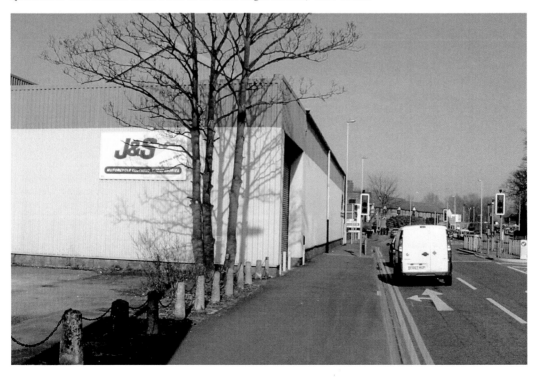

Northwich posters

No longer politically correct but fine in 1920 is this advert for a smoking concert at Winnington Works, a treat for ex-servicemen from the First War. Further back in 1898 a workers' meeting was to be held in the Primitive Methodist school room in Witton Street. Hopefully the buildings subsidence would not interfere with proceedings!

SUPPER

: : *and* : :

SMOKING CONCERT

to EX-SERVICE MEN in the

employ of Brunner, Mond & Co. Ltd.

(WINNINGTON WORKS).

Monday, February 16th, 1920.

Northwich and District Amalgamated Society of
Salt Workers, Rock Salt Miners, Alkali Workers,
Mechanics and General Labourers.

NOTICE.

THE

ANNUAL MEETING

OF THE ABOVE SOCIETY, WILL BE HELD IN THE

PRIMITIVE METHODIST SCHOOL-ROOM,

WITTON STREET, NORTHWICH,

On SATURDAY, JANUARY 8th, 1898,

FOR THE TRANSACTION OF THE FOLLOWING BUSINESS:

1st.	- - -	The President's Address
2nd.	- - -	The Secretary will read the Half-Yearly Report and
3rd.	- - -	The Election of President (Balance Sheet
4th.	- - -	The Election of Vice-President
5th.	- - -	The Election of Stewards
6th.	- - -	The Election of Cardmarker
7th.	- - -	The Election of Committee

After the Election of Officers, other Important Business will be placed before the Meeting for discussion.

All Members who can possibly make it convenient to attend, are earnestly requested to do so, and bring their Cards with them for admission, as none but members will be admitted.

Doors open at 6·45 ; Business to commence at 7 o'clock prompt.

Yours respectfully,

WM. YARWOOD, Secretary.

Wincham, Northwich, January 1st, 1898.

H. BATESON & Co., PRINTERS, BULL RING, NORTHWICH.

Acknowledgements

The basis of this book is a collection of photographs held at the Weaver Hall Museum and Workhouse and I would like to thank the Cheshire West & Chester Council for giving me permission to make use of them and the museum Curator, Matt Wheeler, for his invaluable assistance in the compilation of the book. I would also like to thank Mrs Dobbie, Mrs Christy, Colin Edmondson and Bill Gregory for their kind offer of old photographs. My wife Rose for her patience and finally the people of Northwich who, many years ago, had the foresight to photograph their town for posterity.

About the Author

Paul Hurley is a freelance writer and author with magazine and book credits to his name. He lives in Winsford with his wife.

Front Cover
High Street Junction, Crown Street, 1892 and 2009, and 1950s and 2009

Back Cover
Northwich Station between 1900-1909 and 2009